THE EMPERORS' NEEDLES

EGYPTIAN OBELISKS AND ROME

SUSAN SOREK

BRISTOL
PHOENIX
PRESS

First published in 2010
by Bristol Phoenix Press
an imprint of The Exeter Press
Reed Hall, Streatham Drive
Exeter EX4 4QR
UK
www.exeterpress.co.uk

British Library Cataloguing in Publication Data
A catalogue record for this book is available
from the British Library.

Harback ISBN 978 1 904675 51 8
Paperback ISBN 978 1 904675 30 3

Mixed Sources
Product group from well-managed
forests and other controlled sources
www.fsc.org Cert no. SA-COC-002112
© 1996 Forest Stewardship Council

Typeset in Chaparral Pro 11.5pt on 14.5pt
by JCS Publishing Services Ltd, www.jcs-publishing.co.uk

Printed in Great Britain by Short Run Press Ltd, Exeter

CONTENTS

 of Egypt 137
 Conclusions 147

 Appendix: Translations of Two Obelisk Inscriptions *151*
 Bibliography *159*
 Index *161*

ILLUSTRATIONS

Bold numbers relate to the list on pp. xiii–xv.

PREFACE

For thousands of years obelisks dominated the skyline of Egypt, standing in pairs in front of the temples, their tops glistening gold. On the shafts were inscriptions that proclaimed the triumphs and glory of the pharaohs, a monumental testament to a civilization that came to have a profound effect in shaping world history. In many Egyptian texts the pharaohs declared that obelisks touched, pierced or mingled with the sky, and consequently reached heaven.

It was early contact with Greece, and later and more significantly Rome, that ensured that Egypt's history was not forgotten. The Greeks gave the name 'obelisk' to these monuments and this is how they have been known ever since. But it was under the Roman emperors that large-scale movement of obelisks from Egypt began.

Today, numerous obelisks lie in pieces scattered across Egypt, while others are in museums around the world. However, twenty-eight obelisks of Egyptian origin are still standing, of which six remain in Egypt. Rome boasts the majority of the remainder, having fifteen in total. The monoliths that once proclaimed the glory of the pharaohs can now be seen in every corner of the Eternal City. During the medieval period they were used as landmarks to guide pilgrims to the holy Christian sites. Anyone visiting Rome today cannot fail to be impressed by the obelisks' size, and intrigued by the hieroglyphs inscribed on the shafts. The stones bear testament to a history thousands of years old, standing as silent witnesses to mankind's endeavours. Yet, each obelisk has its own tale to tell: its own unique version of the past.

There is at present no general work available that charts the journey of these obelisks to the West, yet there is a plethora of material on the pyramids, hailed as masterpieces of precision engineering. Obelisks are just as fascinating, providing a different example of the ingenuity of ancient technological skill.

This book examines how and why the obelisks travelled to the West and Rome's role as prime mover. To enable the reader to have a clearer understanding of the history of the obelisk, the Introduction provides a brief history of Pharaonic Egypt, the various time periods and developments. Chapter 1 gives the history of the development of the obelisk, while Chapter 2 looks at how obelisks were made and transported to their original locations by the ancient Egyptians.

Where possible, Egyptian texts are used, but only a few actually mention obelisks, so it is necessary to rely upon Greek or Roman texts to fill in some of the gaps. The Greeks and Romans did not fully understand the meaning or religious symbolism behind these monuments, so their version is not always reliable; without their input, though, we would know even less. There is still much to be learned: despite the best attempts by modern archaeologists and engineers, the actual mechanics of the obelisks' erection in ancient times is still something of a mystery.

From Chapter 3 onwards, the book focuses on how and why these monuments were moved to the West. As the book's title highlights, it was the Roman emperors who first began to move the obelisks out of Egypt to adorn the capital of their new empire, Rome, at considerable expense. Did they remove these gigantic monuments purely as victory trophies, or did they have other agendas? It seems clear that when the Roman emperor Augustus established his rule, he intended that it should receive divine sanction. The powerful images embedded in Egypt's monuments fulfilled that need, and set a trend that was to have a profound influence throughout the Western world for nearly two thousand years.

Each obelisk has its own story, and this will be told in detail: the history of each one's survival and its travels, up to its present-day location. Chapters 14 to 16 will examine some of the obelisks that

were removed from Egypt later on, in the nineteenth century, and re-situated in the capitals of London, Paris and New York. Naturally the final words must concern the obelisks that still stand in their homeland, and so the final chapters brings the work full circle, back to Egypt.

I am most grateful to David Noy for translating the inscriptions on pages 41, 51 and 69. Figures 1, 4 and 13 have been provided courtesy of Lucy Burnett, Figure 12 is reproduced by kind permission of Keith Hopwood, UWL; all other photographs are my own.

For ease of reference, each obelisk is numbered in the text as per the list on pp. xiii–xv.

Susan Sorek
August 2009

Standing Obelisks and their Present Locations

There are currently twenty-eight Egyptian obelisks scattered throughout the world; of these, Rome has by far the largest collection: fifteen in total; six of these were quarried in Egypt on the orders of various Roman emperors, and are sited at various locations in the city. The following list refers to all the standing Egyptian obelisks discussed in the text, alongside the pharaohs they commemorated and their location. Each obelisk is numbered and these bold numbers are used to identify the obelisks throughout the text.

Emperor/Pharaoh	*Present Location*
	ITALY
1 Augustus/ Psammetichus II	Piazza di Montecitorio, **Rome**
2 Augustus/Seti I	Piazza del Popolo, **Rome** (Flaminian obelisk)
3 Augustus/Hophra	Piazza della Minerva, **Rome**
4 Augustus/Hophra	Piazza del Rinascimento, **Urbino**
5 Caligula/uninscribed	St Peter's Square, **Rome** (Vatican obelisk)
6 Claudius/ Ramses II	Boboli Gardens, **Florence**

	Emperor/Pharaoh	Present Location
7	Claudius/ Ramses II	Viale delle Terme di Diocleziano, **Rome**
8	Domitian/ Ramses II	Piazza della Rotonda, **Rome**
9	Domitian/ Ramses II	Villa Mattei, **Rome**
10	Domitian/Roman	Piazza Navona, **Rome**
11	Hadrian/Roman	Monte Pincio Gardens, **Rome**
12	Third century AD?/ Ramses II	Trinità del Monte, **Rome**
13	Constantine I/ Constantius II/ Tuthmosis III	Piazza di San Giovanni in Laterano, **Rome**
14	First century AD?/ uninscribed	Piazza del Quirinale, **Rome**
15	First century AD?/ uninscribed	Piazza del Esquiline, **Rome**

TURKEY

16	Theodosius I/ Tuthmosis III	Atmeidan Square, **Istanbul**

FRANCE

17	Ramses II	Place de la Concorde, **Paris**
18	Constantine I/ uninscribed	Place de la République, **Arles**

ENGLAND

19	Tuthmosis III	Thames Embankment, **London** (Cleopatra's Needle)
20	Ptolemy IX	Kingston Lacy House and Park, Wimborne, **Dorset**

Emperor/Pharaoh	*Present Location*
	USA
21 Tuthmosis III	Central Park, **New York**
	ISRAEL
22 Unknown/Roman?	Ruins of Hippodrome, **Caesarea**
	EGYPT
23 Sesotris I (Senusert)	Among ruins on Cairo Road, **Heliopolis**
24 Tuthmosis I	Temple of Amun, between third and fourth pylon, right side, **Karnak**
25 Hatshepsut	Temple of Amun, between fourth and fifth pylon, left side, **Karnak**
26 Ramses II	In front of first pylon, left side, **Luxor Temple**
27 Ramses II	Al Andalus Gardens, Gezira Island, near to Cairo Tower, **Cairo**
28 Seti (Sethos) II	Temple of Amun, before first pylon, right side, **Karnak**

CHRONOLOGIES

All rulers' and popes' dates are the dates of rule/office, not dates of birth and death.

Because of the huge span of history covered, only the people and events that are related to the obelisks and mentioned in this book can be included here.

Pharaonic Egypt

Dynasty	Ruler	Obelisk/event

Early Dynastic Period

2920–2770 BC, First Dynasty		
2770–2649 BC, Second		
2649–2575 BC, Third		

Old Kingdom

2575–2465 BC, Fourth		
2465–2323 BC, Fifth		Sun temples built at Abusir and Saqqara
2323–2150 BC, Sixth		
	2323–2291 BC Teti	
	2291–2269 BC Pepi I	
	2269–2175 BC Pepi II	Sabni transports two obelisks to Heliopolis for Pepi II
2150 BC, Seventh		
2150–2134 BC, Eighth		

Dynasty	Ruler	Obelisk/event

First Intermediate Period

2134–2040 BC, Ninth/Tenth

2134–2040 BC, Eleventh (Theban)

Middle Kingdom

2040–1991 BC, Eleventh (All of Egypt)

1991–1783 BC, Twelfth

	1971–1928 BC Sesostris I	1972 BC Sesostris I sets up obelisk **23** at Heliopolis
		1968 BC Sesostris I builds new temple at Heliopolis

1783 BC, Thirteenth

1783–1640 BC, Fourteenth

Second Intermediate Period

1640–1532 BC, Fifteenth

1600–1550 BC, Sixteenth (minor Hyksos kings)

1640–1550 BC, Seventeenth

New Kingdom

1550–1307 BC, Eighteenth

1539–1514 BC Ahmose	
1546–1516 BC Tuthmosis I	Tuthmosis I erects obelisk **24** at Karnak
1473–1458 BC Hatshepsut	Hatshepsut sets up obelisk **25** at Karnak
1479–1425 BC Tuthmosis III	Tuthmosis III sets up obelisk **16** at Karnak
	c.1468 BC Tuthmosis III sets up obelisks **19** and **21** at Heliopolis
	Tuthmosis III orders obelisk **13** but dies before it is set up

Dynasty	Ruler	Obelisk/event
	1427–1401 BC Amenhotep II	
	1419–1386 BC Tuthmosis IV	Tuthmosis IV sets up obelisk **13** at Karnak
	1391–1353 BC Amenhotep III	
	1353–1335 BC Akhenaten	Amarna becomes capital
	1334–1325 BC Tutankhamun	Tutankhamun restores old religion
1307–1196 BC, Nineteenth		
	1306–1274 BC Seti I	1300 BC Seti I sets up obelisk **2** at Heliopolis
	1290–1224 BC Ramses II	Ramses II completes inscription on obelisk **2**
		Ramses II sets up obelisks **17** and **26** at Luxor, obelisks **6**, **7** and **8** at Heliopolis and obelisk **27** at Tanis
	1207–1202 BC Seti II	Seti II sets up obelisk **28** at Karnak
1196–1070 BC, Twentieth		
	1194–1163 BC Ramses III	
	1166–1160 BC Ramses IV	

1070–712 BC, Third Intermediate Period

712–332 BC, Late Period

		Fifth century BC – Egypt attached to Persian Empire
		Herodotus visits Egypt
	593–588 BC Psammetichus II	Psammetichus II sets up obelisk **1** in Heliopolis
	586–570 BC Hophra	Hophra sets up obelisks **3** and **4** at Saïs

332 BC–395 AD, Graeco/Roman Period

		332 BC Alexander the Great conquers Persian Empire (and Egypt)

Dynasty	Ruler	Obelisk/event
		323 BC Alexander founds Alexandria
		323 BC death of Alexander

323–30 BC, Ptolemaic Rule

 323–285 BC Ptolemy I

 285–246 BC Ptolemy II Philadelphia

 246–221 BC Ptolemy III — Ptolemy III erects Serapeum of Alexandria

 168 BC Egypt becomes a Roman protectorate

 116–107 BC Ptolemy IX — Ptolemy IX sets up obelisk **20** at Philae

Roman Period

Emperor	Obelisk/event

 51 BC Ptolemy XII dies, leaving kingdom to his children Cleopatra VII and Ptolemy XIII

 48 BC Battle of Pharsalus. Julius Caesar defeats Pompey. Caesar enters Alexandria, defeats Ptolemy XIII and forms alliance with Cleopatra VII

 44 BC Julius Caesar assassinated in Rome

 31 BC Battle of Actium. Octavian (Augustus) defeats Mark Antony and Cleopatra VII

 30 BC death of Mark Antony and Cleopatra VII

 28 BC Augustus' Mausoleum built in Rome

27 BC–AD 14 Augustus

 ? before 26 BC Augustus erects obelisk **5** in Julian forum, Alexandria

 21 BC Agrippa bans Egyptian cults from Rome

 18–12 BC Pyramid of Cestius built in Rome

Emperor	*Obelisk/event*

13–10 BC Augustus brings obelisks **1**, **2**, **3** and **4** (and others) to Rome. Obelisk **1** sited near Altar of Peace as sundial; **2** set up in Circus Flaminius; **3** and **4** set up in Campus Martius or Mausoleum

10 BC obelisks **19** and **21** moved and set up at Alexandria

AD 14–37 Tiberius

AD 19 priests of Egyptian cults deported to Sardinia

AD 37–41 Caligula

AD 37 Caligula imports obelisk **5** from Alexandria to Rome. It is set up in Circus of Nero

AD 41–54 Claudius

Claudius perhaps imports obelisks **6** and **7**, to set up at Iseum. Obelisk **6** possibly set up in Flaminian Circus

AD 54–68 Nero

AD 69 Year of Four Emperors

AD 69–79 Vespasian

AD 79–81 Titus

AD 81–98 Domitian

AD 80 Domitian imports obelisk **8** and sets it up at the entrance to the Iseum in Rome

AD 81–92 Flavian Palace built

AD 81 Domitian imports and sets up obelisk **10** at the Iseum

Domitian imports obelisk **9**. Possibly imports or re-sites **14** and **15** at Mausoleum in Rome and perhaps moves **3** and **4** to Iseum

Emperor	*Obelisk/event*

AD 98–117 Trajan

AD 117–138 Hadrian

AD 131 Hadrian builds funerary temple at Antinoopolis, including, perhaps, obelisk **11**
Hadrian possibly sets up obelisk **22** in Caesarea

. .

AD 220 Obelisk **11** perhaps moved or first set up in Circus Varianus
Third century AD Obelisk **12** perhaps first set up at Hadrian's palace in Tivoli

. .

AD 306–312 Maxentius (Western Empire)

Maxentius moves obelisk **10** to circus on Appian Way

AD 307–337 Constantine I 'the Great' (Eastern Empire)

Constantine I moves obelisk **18** from Egypt to set up in Arles.
AD 337 Constantine I moves obelisk **13** from Karnak to Alexandria, ready to export to Constantinople

AD 337–361 Constantius II

AD 357 Constantius II imports obelisk **13** from Alexandria to the Circus Maximus, Rome

. .

AD 379–395 Theodosius

Theodosius has obelisk **16** moved from Egypt to Constantinople

. .

AD 410 Sack of Rome by Alaric. Obelisk **12** perhaps pulled down in gardens of Sallust

Medieval to Modern Periods

? 13th century Obelisk **9** re-erected on Capitoline Hill
 1374 Obelisk **8** found during reconstruction of Church of St
 Maria Sopra Minerva. Some time later moved to Via del
 Seminario
 1463 Part of dial of obelisk **1** found
 1503–13 Pope Julius II. Obelisk **1** found buried
 1519 Obelisk **15** excavated and moved
 1582 Obelisk **9** moved to Villa Mattei, Rome
 1585–90 Pope Sixtus V
 1585–86 Fontana re-erects obelisk **5** in St Peter's Square, Rome
 1587 Fontana re-erects obelisk **15** in Piazza del Esquiline,
 Rome
 1588 Fontana re-erects obelisk **13** in Piazza di San Giovanni
 in Laterano, Rome
 1589 Sixtus V re-erects obelisk **2** in Piazza del Popolo, Rome
 1587 Sixtus V orders obelisk **1** to be re-erected, but project
 abandoned
 1572–85 Pope Gregory XIII
? 17th century Obelisk **6** set up in Boboli Gardens, Florence
 1644–55 Pope Innocent X
 1647 Bernini re-erects obelisk **10** in Piazza Navona, Rome, for
 Innocent X
 1655–67 Pope Alexander VII
 1667 Obelisk **3** cleared and re-eretcted in Piazza della
 Minerva, Rome
 1700–21 Pope Clement XI. Clement XI moves obelisk **8** to Piazza
 della Rotonda
 1730–40 Pope Clement XII. Obelisk **12** transported to Piazza di
 San Giovanni
 1737 Obelisk **4** re-erected in Urbino
 1740–58 Pope Benedict XIV
 1748 Obelisk **1** moved from Piazza del Parlamento
 1769–72 Pope Clement XIV. Obelisk **11** given to Clement XIV
 by Domina Cornelia Barberini, transported to Pigna
 gardens in the Vatican
 1772–99 Pope Pius VI. Obelisk **12** re-sited in Trinità del Monte
 1786 Obelisk **14** re-erected in Piazza del Quirinale, Rome
 1792 Pius VI sets up obelisk **1** in Piazza di Montecitorio

1800–23 Pope Pius VII
1833 Obelisk **17** moved to Paris
1822 Obelisk **11** set up in Monte Pincio gardens, Rome
1839 Obelisk **20** moved from Egypt and set up at Kingston Lacy, Dorset, UK
1878 Obelisk **19** moved from Alexandria to London
1881 Obelisk **21** moved from Alexandria to New York
1883 Obelisk **7** excavated
1887 Obelisk **7** set up at Rome railway station
1924 Obelisk **7** removed from Termini and set up in Viale delle Terme, Rome
1958 Obelisk **27** moved from Tanis to Cairo
2001 Obelisk **22** set up in Caesarea, Israel

INTRODUCTION

THE HISTORY OF PHARAONIC EGYPT

A ncient Egypt owed its existence to the fecundity of the river
Nile. As well as irrigation, the annual flooding brought a
black silt rich in minerals to the floodplain, an excellent soil for
growing crops. The river thus created a wide fertile valley in the
desert and along its banks one of the oldest civilizations in the
world began.

Discoveries of stone tools in the Nile Valley show that Neolithic
communities existed in Egypt as early as 7000–6000 BC. By 3200–
3000 BC, these communities were united under one ruler, Menes,
who founded the first of the Egyptian dynasties that ruled Egypt for
nearly three thousand years. It was Menes and the two succeeding
dynasties who unified Lower and Upper Egypt, ruling from the
capital at Memphis, and established the world's first great empire.
The first pharaoh, Menes (c.2920 BC), founded the city of Memphis
as the centre of national administration, and it remained so for
more than eight centuries. The city's principal deity was Ptah, the
creator of mankind and the patron of the arts.

The fifth-dynasty kings had a special reverence for the sun god,
Rā, which they demonstrated by building sun temples not far from
their own mortuary temples, the necropolis of Memphis, on the
plateau of Abusir north of Saqqara. Excavations carried out by the
German archaeologist Ludwig Burchardt (1863–1938) revealed the
layout of one complex, the sun temple of Neuserre (2449–2417 BC).
The dominant feature of the temple was a large obeliskoid structure
that stood upon a high truncated pyramid.

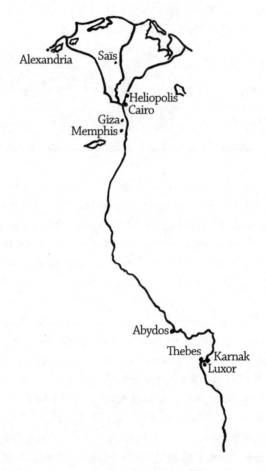

1 *Map of ancient Egypt*

This was not a monolith like the later true obelisks, but was composed of separate blocks. It would have been about 36 metres (118ft) high when complete and its *pyramidion* (the cap at the top of the column) would have stood some 56 metres (184ft) above the court of the temple. The temple and the 'obelisk' were covered in white limestone that would have reflected the rays of the sun in great splendour.

* * *

The fourth and fifth dynasties ruled Egypt between 2575 BC and 2323 BC (the start of the Old Kingdom), and they also had their capital in Memphis. The kings of these dynasties built huge tombs, which can still be seen today at the sites of Giza, Saqqara, Abusir and Dahshur. It was at around this point that the political and social structures of the empire also began to evolve, becoming more complex but at the same time more stable, headed by the semi-divine pharaoh who wielded absolute temporal, religious and military power.

The once great city of Heliopolis now lies in ruins, just to the south of modern Cairo. The city became important at a date even earlier than that of Memphis. The Egyptians called it Anu Meht (Northern Anu), to distinguish it from Anu Rest, which lies a few miles to the south of Thebes. The city formed the terminus of caravan roads from the north, west and south, and was consequently a flourishing centre of trade. It was home to many religious cults, the foremost of which was that of the sun god, whose various forms were in early times called Kephera or Atem. Heliopolis was known to the Hebrews as On or Aven, and the Bible tells of Joseph's marriage to a daughter of a priest of On (Genesis 41: 5; Ezekiel 30: 17).

A later story concerned a famous well in which—according to tradition—the sun god Rā bathed his face when he rose for the first time on the world. The well is still there, at Matarîyah, and is known in Arabic as Ain ash-Shems (Fountain of the Sun). The Apocrypha of the Greek New Testament recounts that the Virgin Mary rested by this well and drew water from it to wash the clothes of the baby Jesus. Wherever the water fell, balsam plants sprang up; drops of their oil were mixed with the water used to baptize Christians.

Until the 1970s, Heliopolis had produced no obelisk that could be dated earlier than the Middle Kingdom (2040–1640 BC), so it was presumed that the obelisks of that period were the earliest true ones ever made. Then the Egyptologist Habachi discovered an inscription indicating that obelisks had existed several centuries earlier (Habachi 1978: 40–1). The inscription was the work of Sabni,

governor of the Aswan area under the sixth-dynasty pharaoh, Pepi II (2269–2175 BC). It recorded Sabni's journey south to northern Nubia in order to construct two large ships to transport obelisks to Heliopolis. Sabni accomplished his mission successfully and brought his workmen safely back 'without the loss of even a single sandal'. The obelisks referred to in the inscription have so far not been found, but it seems highly unlikely that Sabni would have recorded his achievement so fully had the monuments failed to arrive in Heliopolis.

Inscriptions on the walls of the burial chamber of Pepi I, father of Pepi II, reveal the phrase '*tekhenui en Rā*', which had previously been interpreted as 'two pillars of Rā', but Habachi's discovery suggests that the phrase might be more correctly interpreted as 'two obelisks of Rā'.

Further discoveries made in 1972 indicate that there may have been an even earlier obelisk standing at Heliopolis. While taking soundings around the surviving obelisk of the later pharaoh Sesostris I (**23**), the Inspector of Egyptian Antiquities discovered two large blocks of quartzite, each covered with the name of Teti (2323–2291 BC), the founder of the sixth dynasty, and father of Pepi I. One block was part of a door lintel, the other the upper part of an obelisk, which must have stood approximately 3 metres (10ft) high. Only one side of its shaft is inscribed and this preserves two of the king's names: 'Horus Sehetep-tawy the King of Upper and Lower Egypt; the son of Rā, Teti'. This appears to be the earliest royal obelisk so far recovered from Heliopolis.

Sometime during the period 2150–2134 BC, the last of the Old Kingdom dynasties collapsed, and internal squabbles broke out. This anarchic period, (2134–2040 BC) is generally referred to as the First Intermediate Period. During this period, some of the princes of the warring Theban clans gradually began to consolidate their power, and at the same time the pharaohs of the ninth and tenth dynasties managed to re-establish monarchic rule at Heracleopolis, near to modern Asyut. Their reign was short lived, and Mentuhotep

II, the Theban king of the eleventh dynasty, finally put an end to civil unrest.

This rule of the Theban kings is known as the Middle Kingdom, and spanned the years 2040–1640 BC. Their capital was initially at Luxor, but during the eleventh and twelfth dynasties it was moved to the north at Lisht. Meanwhile, Abydos in Upper Egypt became a major religious centre, giving birth to the cult of Osiris.

Sesostris I (1971–1928 BC) was the second king of the twelfth dynasty, and it appears that in the third year of his reign (1968 BC) he built a new temple at Heliopolis in honour of the sun god, with obelisks at the entrance.

The ruins of Thebes lie close to the modern town of Luxor. On the east bank was the City of the Living, and in the middle of the city stood Karnak, a group of temples occupying an area of about 60 hectares (150 acres); this was the national shrine of Egypt for more than two millennia. In the southern suburb stood the temple of Luxor, and the route between Karnak and Luxor was an avenue of sphinxes, along which were the royal palaces, villas and other important buildings of the city.

On the west bank of the river Nile was the City of the Dead. The complex of royal funerary temples and rock-cut tombs stretches for almost two miles along the edge of the desert. To the north lies the Valley of the Kings, where the rulers of Egypt and some of the nobility were buried. To the south is the Valley of the Queens, where royal queens and princess were interred. In between were hundreds of tombs belonging to lesser royals and members of the nobility.

Between 1640 BC and 1532 BC, Egypt was again plunged into disorder, in what is known as the Second Intermediate Period. This time the cause was external: the invasion of the Asiatic tribe known as the Hyksos. The Hyksos settled first in the fertile Nile Delta, where they built their capital, Avaris; from there they moved south into the Nile Valley. The Theban princes fought valiantly against this new wave of invaders, until Ahmose (1539–1514 BC) managed

to drive them out. He founded the eighteenth dynasty, his reign marking the start of the New Kingdom (1550–1070 BC).

The New Kingdom period is generally considered to be the time of Egypt's real greatness: the pharaohs now ruled over a kingdom that stretched from the fourth cataract of the Nile (Sudan) to the Euphrates river valley (modern Iraq). The feats and accomplishments of the rulers of this dynasty are recorded in hieroglyphs such as those seen at the temple of Karnak near Luxor.

During the Second Intermediate Period great wealth had flowed into Egypt, which the pharaohs used to enhance their capital city with all manner of monuments. As a result, Thebes became one of the most important centres of civilization – so much so that, even when its political importance declined, it was still a thriving religious centre. The largest Theban obelisks date to the eighteenth dynasty, and some are still in situ. The majority of them stood in the two great temples of Karnak and Luxor; three still remain standing there (**25, 26, 28**). Tuthmosis I, the dynasty's third king, erected a pair at Thebes, of which one is still standing (**24**).

The pharaoh Amenhotep IV, later known as Akhenaten (1353–1335 BC), veered away from orthodoxy and instigated the cult of the one true god, Aten, who is represented on reliefs as a solar disc. Akhenaten also moved the capital from Thebes to Amarna, near modern El-Amarna. When Akhenaten died, his religion died with him; his son and heir Tutankhamun (1334–1325 BC)—perhaps the most famous of all the pharaohs—restored the old religion. He reigned only nine years and his sudden and perhaps suspicious death at the age of nineteen ended the eighteenth dynasty.

It was the objective of Seti I (1306–1274 BC), the second pharaoh of the nineteenth dynasty, to set about restoring the ways of the Old Kingdom. He and his son and successor Ramses II (1290–1224 BC) built some of the most visually powerful monuments that still survive today. Among his great building projects were the vast tombs at Thebes, the magnificent colossi of Abu Simbel and the temple of the Ramesseum on Luxor's west bank.

With the start of the twentieth dynasty in 1194 BC under

Ramses III, the long decline of the pharaohs' power and kingdom began. Egypt was under attack from all sides. Between the end of the twentieth dynasty in 1070 BC and the conquest of the kingdom by Alexander the Great in 330 BC, few dynasties lasted more than 150 years. The centre of power moved from the Delta to Upper Egypt and back again. A Libyan dynasty ruled from Tanis, which in turn gave way to a Nubian dynasty that conquered Upper Egypt, and eventually the whole empire. Their capital at Thebes was then pillaged by Assyrian invaders.

Throughout the fifth century BC, Egypt was attached to the Persian Empire, which was finally defeated by Alexander the Great in 332 BC. On the death of Alexander, his most brilliant general crowned himself Ptolemy Soter (Saviour) I, and began the Ptolemaic dynasty. Its last, and perhaps most famous, 'saviour' was Cleopatra VII (49–30 BC), whose liaisons with Julius Caesar and Mark Antony eventually led to Egypt becoming part of the Roman Empire in 30 BC. Egypt would remain in Roman control for the next seven centuries, and in the process see many of its greatest monuments removed.

CHAPTER 1

THE CULT OF THE SUN STONE
THE ORIGINS OF THE OBELISK

A t some point in history, so long ago that it cannot be dated
with any accuracy, the people of the Egyptian town of Iunu
(Anu, meaning pillar), had as a cult object a stone that was thick
at the base and tapered to a point at the top. Iunu is better known
today by its Biblical name of On or its Greek name of Heliopolis,
which is how it is referred to in this book. This early stone was called
the Ben stone, and it is represented in texts of the sixth dynasty as
a small obelisk surmounted by a little pyramid (*pyramidion*). This
stone was the fetish of the primeval god Atum (the setting sun) and
the god Rā or Rā-Harakhti (the rising sun). How the stone acquired
its sanctity is unknown and it is possible that the ancient Egyptians
had no clear idea of its origins either.

The Egyptian kings of the fifth dynasty (2465–2323 BC) built
temples in connection with their pyramids at Abusir and Saqqara.
They had a stronger allegiance to the sun god Rā and his priesthood
than previous dynasties had, and in their temples the sun stone (or
Ben stone) was the principal symbol of Rā, who was now represented
in human form. This fifth-dynasty stone was a short thick obelisk
structure standing on a base that resembled a truncated pyramid
(see Fig. 2). On the east side of the stone was an altar where victims
were sacrificed, and on the north side was a channel where the blood
of the victims was collected in strategically placed alabaster bowls.

The apex of the stone was believed to house the spirit of
the sun god, from where he could witness the slaughter of the
sacrificial victims and accept the offerings that were made to him.

Consequently, the apex was the most sacred part of the structure; this was called the Benben (the Ben of the Ben).

The pyramids of the last kings of the fifth and the early kings of the sixth dynasty (between 2345 BC and 2181 BC) decorated the walls of their burial chambers with religious texts. These writings, known as the Pyramid Texts, were concerned with the deceased's welfare. One text, confirming that the spirit of the deity dwelt in the Benben, reads:

> O Atum, the Creator. You became high on the height, you rose up as the benben-stone in the mansion of the Phoenix in Heliopolis. (Pyramid Text no. 1652, Faulkner 1969: 242)

* * *

It used to be thought by Egyptologists that the obelisk developed out of the Ben stone by the addition of a long shaft, but the Pyramid Texts demonstrate this was not the case. These early 'obelisks'—called *tekhenu* in the texts—had pyramidal tops like the Ben stone, but they were simply pillars that the Egyptians set up before the doors of their temples or shrines for ceremonial purposes. The meaning of the word *tekhenu* remains uncertain: although it appears on inscriptions as early as the sixth dynasty, it seems that even by

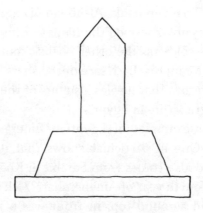

2 *The original Ben stone*

then the word was an ancient one whose meaning may well have been long forgotten.

The *tekhenu*, symbolizing rebirth, was used initially as a funerary monument. The belief was that it brought into the tomb the reviving rays of the sun to allow the resurrection of the deceased. The small calcareous stone stelae found in the graves of the Pre-Dynastic and Archaic periods (c.3000–2575 BC) were resting places for the spirits of the dead when they came to the graves to partake of the spiritual parts of the offerings laid out for them. The much later New Kingdom wooden sepulchral stelae display wooden figures of human-headed hawks, indicating that the stones and tomb stelae, irrespective of the material from which they were made, were regarded as dwelling places of the dead. According to E.A. Wallis Budge, 'The stelae found in the first- and second-dynasty tombs at Abydos (2920–2649 BC) are rough slabs of grey granite that only had one dressed face, ready to receive an inscription' (Budge 1926: 5). These stelae were the precursors of the obelisk that appeared a little later, during the fourth dynasty (2575–2465 BC), when it became customary to place a pair of small stone obelisks on each side of a false door in the tomb.

Budge describes two small inscribed obelisks from the twelfth dynasty (1991–1783 BC) in the British Museum (1926: 6). One was about 51 centimetres (20in) high and was set up in memory of an official, or possibly a soldier stationed at the copper mines of Sarābît al-Khâdam in the Sinai Peninsula. Although his name is not legible, on two of the sides are inscribed the names of his sons, Aqen and Ahnem, who were soldiers. The other obelisk commemorates Ara, the high priest of Memphis. Each face of the shaft is inscribed with hieroglyphs that record that he was also one of the directors of the Department of Agriculture in Egypt.

There are other examples of Egyptian funerary stelae in the British Museum. One in particular shows that it is part obelisk and part stele, and also comes from Sarābît al-Khâdam, giving the date as the forty-fourth year of Amenemhat(?) III. It has sides that taper upwards and a round top; in front was a rectangular slab with hollows, indicating that it was an altar on which offerings

to the dead were placed. The Arab physician 'Abd al-Latif, who visited Egypt in the twelfth century AD, records that he saw many obelisks at Heliopolis, and several were quite small. These had most probably been set up as funerary monuments intended to indicate resurrection in the afterlife.

Many uninscribed obelisks, varying in height from 1 to 2 metres (3–6ft), have been found in the New Kingdom tombs in the areas around Memphis and Heliopolis. Their presence in these funerary sites suggests that they represented memorial pillars or markers to places where offerings for the dead should be left. Others were inscribed on one face only, usually with the name and title of the tomb occupant, in the same manner as the names carved on the door lintels of some tombs in the Old Kingdom period. Those found in the Memphis cemeteries belonged to important people, usually related to, or in the service of, the royal family. One pair of obelisks was inscribed with the name of Sheshi, 'the scribe of the *phylae* [district] of Heliopolis and of the troops'. Another bore the name of Neit, a wife of the sixth-dynasty pharaoh, Pepi II. Some also include prayers addressed to the gods by the dead person. The majority of these objects are positioned to face east and may well relate to the sun god, who also acted as a guide to the underworld.

It was the kings of the fifth dynasty (2465–2323 BC) who developed the idea of the obelisk. They erected pyramids to serve as their burial places, but the pyramid was only the focus of a large funerary complex that had a mortuary temple at the base of the pyramid, connected by a causeway to another temple. To demonstrate their especial reverence for the sun god, these fifth-dynasty kings added a gigantic *tekhenu* as the main feature of their complex pyramid structures, as a focus for the deity's spirit.

From this point onwards, obelisks became free-standing struc-tures, although there were still also funerary obelisks, developed to mark the entrances to certain tombs. Later, these obelisks became larger and heavier than the funerary stelae. It appears that obelisks did not supersede the Ben stone, but incorporated the Ben stone ideology: Rā was eternal and the obelisk symbolized stability and

permanence, incorporating all the powers of rebirth and fertility that the god possessed. The top of the obelisk, the *pyramidion*, was still called the Benben.

In a much later inscription from the tomb of Seti I (1306–1274 BC), the god Benbeniti is said to be one of the seventy-five forms of Rā. It would appear that the Ben stone and the Benben of the obelisk symbolized the creative power of the sun god; the word '*ben*' and all its variants indicate 'virility' and 'reproduction'. It is also clear from the texts that, during certain dynastic periods, obelisks were believed to be occupied by a god and so entitled to offerings. Thus, Ben stones and *tekhenu*, both dedicated to the sun god, represent the various aspects of religious ideology that had evolved throughout the centuries.

The obelisk is made up of two parts, the shaft and the *pyramidion* (little pyramid) at the top of it. The shaft could be considered as a standing stone or pillar in honour of the sun god, and the *pyramidion* as the symbol of the rays of the sun as they spread out when they hit the earth. The Roman writer Pliny the Elder (AD 29–73) says that obelisks were meant to resemble the rays of the sun (*Natural History* 36: 14). The shaft and the *pyramidion* were sacred to the sun god, represented as the sun, giver of life and warmth.

The oldest obelisk (**23**), still standing at the site of Heliopolis, is that of Sesostris I (1971–1928 BC), the second king of the twelfth dynasty; it tells us that the king set up this monolith on the occasion of his first celebration of the Set festival. The word '*set*' means a tail, and it is thought that the festival was originally celebrated in connection with the assumption of a lion's tail by the king as part of his ceremonial dress. At first the festival was celebrated in the king's thirtieth year, although the intervals between festivals within a king's reign tended to become shorter.

If we compare the Sesostris inscription with the inscriptions left by the kings of the eighteenth dynasty (1550–1307 BC), we can see that the kings stated quite definitely that they had set the obelisks up, not as part of the Set festival, but in honour of the god Rā or

Amun-Rā, in order to obtain eternal life from the gods. Ramses II 'set up two great obelisks' (*tekhenui urui*), as did Hatshepsut, in the hope of eternity. The obelisk (**25**) of Queen Hatshepsut (1473–1458 BC), which still stands at the temple of Karnak, describes her as: 'the one for whom her father Amun established the name Makare upon the *Ashed*-tree [a tree of eternity] in reward for this hard, beautiful and excellent monument which she made for her First Jubilee'.

The inscriptions on the shafts of the monumental obelisks give the various names of the pharaoh who had set them up. On some obelisks there are references to royal victories, but these are rarely actual historical events. The *pyramidion* usually contains vignettes—ornamental designs—in which the pharaoh is shown worshipping the god Rā or Amun-Rā and making him offerings. A vignette from the fifteenth chapter of the Book of the Dead, a guide to the dead in their travels through the underworld, is captioned 'Adoring Rā-Harakhti when he rises in the eastern horizon of the sky'. In this manuscript we see two obelisks in front of a huge number of offerings: cakes, fruit, geese, meat, flowers and other goods. A priest stands before an altar and behind him is another, who recites the service of the offerings from a papyrus.

On the obelisk in the Piazza di San Giovanni in Laterano (**13**) Tuthmosis III is shown making offerings at his four obelisks, which included vast amounts of incense, myrrh and hundreds of different cakes. The inscriptions that accompany these vignettes make it clear that the pharaoh, who kneels before the god, owes his life, health, strength and stability to the deity.

The correct orientation of any obelisk can be ascertained by the direction in which the hieroglyphs of the inscriptions face. Hieroglyphic inscriptions, whether horizontally or vertically written, can be read either from right to left or left to right, but the hieroglyphs normally face towards the beginning of the inscription. The hieroglyphs on the front of the obelisk—usually a dedicatory inscription—and those on the back both face towards the entranceway to the temple. Therefore, for any obelisk there is only one correct orientation.

* * *

The obelisk had its heyday under the periods of the Middle Kingdom (2040–1640 BC) and the New Kingdom (1550–1070 BC). Amenhotep III, the ninth king of the eighteenth dynasty (1391–1353 BC), tells in his inscription at Karnak that he placed in the great sacred barge, two large obelisks made of cedar wood and plated in gold and silver, and at Thebes he dedicated them in honour of Amun-Rā, king of the gods.

It was during the New Kingdom, a time of empire building, that obelisks came to play a significant role as an architectural feature in association with temples. The kings of the eighteenth dynasty used them to adorn the temples of Karnak and other religious sites at Thebes, and the Ramesside kings of the twentieth dynasty (1196–1070 BC) fashioned obelisks for their new capital, Tanis, on the Delta. It was during this period that these stone pillars were endowed with supernatural significance; the belief that the obelisks housed the spirits of the deities meant that they merited special offerings and ceremonies. Tuthmosis III instigated new liturgies and practices for the obelisks that he erected at Karnak.

It was believed that the obelisk had a real solar importance. It was positioned according to traditional patterns so that the pillars, which also had to conform to specified heights and positioning, honoured the rising and the setting of the sun. Ramses II gave names to the pair he erected at the temple of Luxor: on the pedestal of the eastern obelisk (**26**) the king boasted that he made a large obelisk called 'Ramses Beloved of Amun' (the rising sun). On the western obelisk (**17**, now in Paris) was the inscription, 'Ramses Beloved of Atum' (the setting sun).

From the very earliest concept of the Ben stone, and the funerary *tekhenu* and stele, the obelisk evolved into a symbol of power and religion. The next chapter will examine how these monuments were made. The huge task of quarrying, inscribing and erecting these monoliths could only be rivalled by the building of the pyramids.

CHAPTER 2

CREATED FROM STONE
HOW EGYPTIAN OBELISKS WERE MADE

The majority of Egyptian obelisks are made from red granite, called *mat* in Egyptian. Others are made from from greenish-black basalt (*bekhen*) and a few small ones from sandstone (*bia*). The largest obelisks are of granite—red or black—hewn from the great quarries on the east bank of the Nile, near modern Aswan. Quarrying was carried out in many places in that region, but the most important quarries were at the islands of Elephantine and Seheil in the Aswan region, and in Shellal opposite the island of Philae.

The Excavation and Removal of the Obelisks

A clue to how obelisks were excavated and carved comes from an unfinished obelisk that remains in the south of the Aswan quarry. This obelisk would have been the largest ever erected, but it cracked while being freed from the quarry bed. Had it been successfully finished it would have stood 41.75 metres (137ft) high—almost double the height of Cleopatra's Needle (**19**)—with a base of 4 metres square (13ft). Weighing 1,150 tonnes (1,168 tons), this would have been the largest piece of stone ever moved by the ancient Egyptians. Reginald Engelbach, an English archaeologist who worked on the obelisk for the Egyptian Department of Antiquities in the 1920s, said of the monument:

> A study of the Aswan obelisk enables the visitor to look with
> different eyes on the finished monuments, and to realise,
> not only the immense labour expended in transporting the
> giant blocks and the years of tedious extraction of stone
> in the quarries, but the heartbreaking failures which must
> sometimes have driven the old engineers to the verge of
> despair before a perfect monument could be presented by
> the king to his god.
>
> A perfect monument teaches us little of their engineering;
> an imperfect or unfinished piece of work may teach us much
> ... The Aswan obelisk is a piece of work that failed, not
> through any fault of the workers, but owing to an unexpected
> fissure in the rock. It must have been galling beyond words
> to the Egyptians to abandon it after all the time and trouble
> they had expended, but today we are grateful for their
> failure, as it teaches us more about their method than any
> monuments in Egypt. (Engelbach 1923: 21–2)

The blocks of granite that would become the obelisk were
detached from their beds by using fire to create fissures, or wooden
wedges that were soaked with water to make them expand and so
crack the rock. Scholars believe that it was only in Roman times
that iron wedges would have been used, as iron was unknown to
the Egyptians at this time. Further proof of this can be seen in
the fact that the obelisk lying at Aswan reveals no chisel marks.
Modern assessments suggest that the obelisk was pounded out of
the surrounding rock with balls of dolerite.

Dolerite is one of the few stones in Egypt that are harder than
granite, and several dolerite balls have been found near the obelisk
in Aswan. Each ball is between 15 and 30 centimetres (6–12in) in
diameter and weighs approximately 3.5–5.5 kilos (8–12lb). These
stones were attached to rammers and would have been repeatedly
dropped vertically by rows of workmen along the lines of the
obelisk. As Engelbach says, 'The trench and pits were therefore not
cut out, but rather bashed out' (Engelbach 1922: 21–2). The whole
operation was a time-consuming task, involving several hundred
men in groups of three: two standing and raising the rammer, while

one squatted to direct the dolerite blow to the correct place. On an inscription at the base of one of the obelisks still standing at Karnak (**25**), Queen Hatshepsut recorded that the work took seven months.

Unfortunately, fissures began to appear at the base of the Aswan obelisk, then at the top and on the south side. After so much effort this would have been a great blow to the engineers concerned. Had the obelisk been perfect its lower side would have been removed from the rock by further pounding. Galleries would then have been driven underneath and filled with wooden planks until first one side, then the other, was detached. The procedure can be verified from the bed of a small obelisk in the same quarry, where it can be seen that it was detached from below by pounding. This initial stage might seem a huge task; the real challenge, however, came in lifting and transporting these huge blocks of stone.

On the walls of a nineteenth-century BC tomb at Bersheh in Middle Egypt, is depicted the transportation of a huge seated statue of the tomb's occupant, which is estimated to have weighed around 60 tonnes. The statue is shown mounted on a sledge pulled by 172 men. There are no rollers placed underneath; instead, a man pours liquid in front of it to act as a lubricant. This led some Egyptologists to believe that rollers were never used, but if that were the case it would have required some eleven thousand men to move the unfinished obelisk. Such a figure seems unlikely, and although no remains of rollers have been found, that is scarcely surprising, as the rollers would have been made of wood, which was a valuable commodity in Egypt and one that would not have been left lying around. On the other hand, it is strange that no pictorial record exists of their use.

Englebach calculated that the obelisk would be moved from the quarry by inserting some thirty levers made from tree trunks in the trench around the obelisk, with suitable packing and handling ropes attached to the levers. 'By using these levers from both sides of the obelisk in turn it could be made to rock backwards and

forwards and gradually be raised by increasing the height at each heave' (Engelbach 1923: 54). When the obelisk had been raised high enough and a path cleared, it could be dragged down the slope to the river, a task that Engelbach estimated would have taken six thousand men to complete.

Early in the twentieth century AD, two wide embankments were still discernable close to the unfinished obelisk, with evidence that heavy blocks had been pulled along them in antiquity. However, the point where the obelisks arrived at the river is not known, nor is the method that was used to load them onto the barge. Engelbach had a theory that the task could be safely accomplished by bringing the barge as close as possible to the bank and by building another embankment around it, so raising the height of the barge. Then the obelisk could be pulled until it was directly over the barge and then let down by removing the infilling.

As a postscript, the quarry at Aswan has recently yielded some further information. Excavations have uncovered the remains of a harbour and 'ship pits' (the pits that were dug to facilitate the easing of the ships carrying the obelisks down the bank to the river). Also retrieved were thousands of dolerite balls, part of an inscription recording the ordering of two obelisks by Tuthmoses III and some deep shafts cut into the rock, thought to have been made to test the quality of the stone. In January 2004 a visitor centre was opened at the quarry by the Egyptian Department of Antiquities, where these items can be seen.

Transporting and Erecting the Obelisk

The obelisk's journey down the Nile would most probably have been undertaken during the annual flood. A series of reliefs from the tomb of Queen Hatshepsut at Deir el-Bahari, near the Valley of the Kings, shows the transporting of a pair of her obelisks from Elephantine Island to Thebes. The two obelisks are pictured end to end on a barge roughly 60 metres (198ft) long. The barge was towed by three rows of boats, nine in each row, with a fourth row

in the lead acting as pilots. A further three boats in which religious ceremonies were performed also accompanied the barge.

The Palermo Stone—so named because it is now in the museum at Palermo, Sicily—is a fragment of diorite that contains information from the early dynasties. The stone is thought to have originally been approximately 215 centimetres long and 60 centimetres high (7ft by 2ft). It was inscribed on both sides with details of the Egyptian rulers, from the pre-dynastic kings through to the Old Kingdom. In effect, it is a list of kings, naming around 120 kings who ruled in Upper and Lower Egypt before the period of unification in 3000 BC. The stone also shows that in the reign of Snofru, the first king of the fourth dynasty (2575–2551 BC), the Egyptians were capable of building seagoing boats of great length and carrying capacity. It is no surprise that in succeeding periods they built boats capable of carrying blocks of stone weighing up to a thousand tonnes.

Another inscription, that of Aneni, one of Tuthmosis I's officials, who lived in the first half of the eighteenth dynasty, sheds light on the style of boat that was used. He says:

> I watched over the erection of two obelisks at the double door of the god's house in stone of granite. I watched over the building of a boat splendid of cubits 120 in its length, cubits 40 in its breadth, to transport these obelisks. [It] arrived safely in good condition, close to the district at the Apt. (Inscription at Karnak, translated by Maspero, in Budge 1990: 126)

Pliny tells us that the feat of transporting the obelisks from Egypt for the emperors Augustus and Caligula was held in much awe, and the boats were the most splendid ever seen: 'Transporting the obelisks to Rome by sea was a more difficult task by far. The ships attracted much interest' (*Natural History* 36: 9–14). He goes on to say that the ship that carried the first obelisk to Rome was dedicated by Augustus and put on display in the port of Puteoli (modern Potzzuoli) as a celebration of the skill of the craftsmen; sadly it was later destroyed by fire. The ship was, of course, the work

of Egyptians: the native skill of boat building had been handed down through the generations, and, as late as the time of the Roman emperors, Egyptians were able to transport obelisks even to places as distant as Rome.

There remained the mammoth task of erecting the obelisk once it had arrived at its destination. There is still much debate among archaeologists, engineers and architects about how this was done, and no definitive answer has yet been reached. Engelbach suggested the following hypothesis:

> A method which is mechanically possible and which meets all observed facts is that the obelisk was not let down over the edge of the embankment, but down a funnel shaped pit in the end of it, the lowering being done by removing sand, with which the pit had been filled, from galleries leading into the bottom of it, and so allowing the obelisk to settle slowly down. Taking this as the basis of the method the form of the pit resolves itself into a tapering square-sectioned funnel— rather like a petrol funnel—fairly wide at the top, but very little larger than the base of the obelisk at the bottom. The obelisk is introduced into the funnel on a curved way leading gradually from the surface of the embankment until it engages smoothly with the hither wall of the funnel. The sand is removed by men with baskets through galleries leading from the bottom of the funnel to convenient places outside the embankment. (Engelbach 1922: 69–70)

The French archaeologist Henri Chevrier (1970), who in the 1960s re-erected the obelisk of Tuthmosis I at Karnak (**24**), has dismissed Engelbach's theory because, as he points out, the obelisk could not bear the stress of being lowered into the funnel with its longer part unsupported in the air. Chevrier suggested that a chamber would have had to be built, and the sand supporting the obelisk could then have been taken out through a hole in the bottom. The obelisk would have been moved along the surface of the sand until it rested at an angle of about 34 degrees. At that point, ropes would have pulled

it into a vertical position. Chevrier's modification of Engelbach's theory offers a plausible explanation of how obelisks may have been erected.

Unfortunately, ancient authors remain tantalizingly silent on this matter. There is a reference in Pliny (*Natural History* 36: 16) that may suggest that the pharaohs employed the use of mechanical devices such as cranes and winches. Probably referring to earlier sources now lost to us, perhaps anecdotes and even Herodotus' information on Egyptian customs, Pliny recounts that Ramesis (perhaps Ramses II) erected an obelisk 120 cubits in height by means of 'machines'. He also includes an interesting tale concerning this operation. The pharaoh feared that the machinery used to raise the obelisk would not be strong enough for the task, so he tied his own son to the top of it to make his workmen take greater care. If the pharaoh in question is Ramses II, he had ninety-six sons and so presumably could afford to risk the life of one at no cost to the dynastic succession. We also learn from the Roman historian Ammianus Marcellinus (*Histories* 17: 4) that the Romans used large numbers of heavy timber beams when they moved the obelisks, but he supplies no further details.

There are no surviving Egyptian records to provide further information on the quarrying and erection of obelisks. Some papyri contain references to the work required on an embankment or to the erection of a colossal monument, but they are silent concerning obelisks. The Anastasi papyrus in the British Museum contains a mathematical problem set for a student by his teacher. It refers to an embankment of the kind possibly needed for the erection of an obelisk. The dimensions given are 730 cubits long and 55 cubits wide, consisting of 120 compartments filled with reeds and beams to a height of 60 cubits; the pupil is asked to find the number of bricks necessary to build the compartments. Further on, the teacher sets another problem concerning the erection of a colossal statue:

> Empty the magazine that has been loaded with sand under the monument of your Lord, which has been brought from

the Red Mountain. It makes 30 cubits stretched upon the ground, and 20 cubits in breadth, —ed[?] with 100[?] chambers filled with sand from the river bank. (Anastasi 1: 14.2–17.2)

The dimensions of the chambers are given and the student is asked to calculate how many men are needed to remove the sand in six hours. The same papyrus also contains a question regarding the number of men needed to move an obelisk although, unfortunately, no dimensions are given. There is, however, on the same papyrus a record from an expedition sent by Ramses IV (1166–1160 BC) to the Wadi Hammamat quarries to bring back some large blocks. The list totals 8,462 men—skilled and unskilled—of whom 800 died.

The Final Touch

Once the obelisk had been set up, the three visible sides would have been available for decoration. First, the faces of the obelisk had to be smoothed and polished by pounding and grinding with balls of dolerite. The inscriptions were set out on the faces in red ochre paint and then the figures and hieroglyphs were cut in with chisels made of copper alloy and polished with emery. During the period when obelisks were decorated the Egyptians did not possess iron tools, and bronze tools were not up to the task of engraving granite. The Egyptologist Sir Flinders Petrie suggested that emery was used for carving purposes, but no one is certain if the cutting material (emery) was used as a loose powder, or was set in the metal tool as separate teeth. Habachi says:

> On Egyptian examples there are long grooves in the faces of the cuts of both saws and drills; and grooves may be made by working a loose powder. But, further, the groove certainly seems to run spirally round a core, which would show that it was cut by a single point . . . The large hieroglyphs on hard stones were cut by copper blades fed

with emery, and sawn along the outlines by hand; the block
between the cuts was broken out, and the floor of the sign
was hammer-dressed, and finally ground down with emery.
(Habachi 1978: 32)

Even when the obelisk had been polished and inscribed, the work
was not complete, for the *pyramidion* had still to be fitted with a
metal casing or cap. The obelisks that 'Abd al-Latif saw at Heliopolis
and wrote about in the twelfth century AD had copper casings on
their *pyramidia*. He noted that rainwater running off the casings
had stained the obelisk shafts almost to their bases.

Tuthmosis I sought to remedy this problem of staining. Several
centuries after these early obelisks he erected two great obelisks
and covered their *pyramidia* in a metal called *tchām*. The word has
been variously translated as 'gold', 'white gold' or 'gilded copper',
though no one is really sure what this was. The Egyptian word for
gold is *nub*, but it is possible that *tchām* is an older—or even foreign
word—for gold. The Romans translated the word as 'electrum',
which was—according to Pliny (*Natural History* 33: 23)—the name
given to the gold ore of the region when it contained a proportion
of silver of over one-fifth. Alternatively, it is highly likely that
tchām was a type of natural gold found in the Sudan, which was
known as 'green gold'. It could produce a very highly reflective
polish.

Tchām was used for the casings of the *pyramidia* throughout the
eighteenth and nineteenth dynasties. Regrettably, we can know
nothing about the style and thickness of such casings, but the
inscription of Queen Hatshepsut that describes her two obelisks
on her obelisk base at Karnak, says: 'I allotted for them [the two
obelisks] refined *tchām*. I weighed [it] out by the *heket* measure,
like sackfuls of grain'. Obviously, huge quantities were needed, if
the precious metal was weighed by the hundredweight and not the
pound, so her *pyramidion* casings must have been made of thick
plates of *tchām*. No trace of them has survived, and no wonder; if
they were covered with such amounts of gold it is probable that they

were stolen during the early years of the heretic king Amenhotep IV (Akhenaten) (1353–1335 BC).

Hatshepsut also used gold on the pyramid shaft; on the base of her Karnak obelisk, it is recorded that:

> She made [them] as her monument to her father, Amun, Lord of the Thrones of Two Lands (Thebes), President of the Apts [Karnak]. She made for him two great obelisks of the lasting [or solid] granite of the region of the South [granite quarries of Aswan]. The upper parts [of them] are *tchām* of the best of all the mountains, and they can been seen [from afar both upstream and downstream?]. The Two Lands are bathed in light when Aten rolls up between them as he rises up on the horizon of heaven.

On Hatshepsut's obelisks (**25**) and on those of her stepson Tuthmosis III (**16**, **21**), grooves with holes to affix plates of gold can clearly be seen on the *pyramidia* and on the upper parts of the shafts. It is also likely that even small obelisks, such as those made by Amenhotep and found at Aswan, were completely covered with gold (perhaps gold removed from Hatshepsut's obelisks). In the annals of the Assyrian king Ashurbanipal (668–626 BC), it is recorded that, when he had conquered the Delta and punished the Egyptians, he set out in 663 BC for Upper Egypt to capture and slay the Nubian king Tanutamen, who had seized Egypt. He says that among the spoils he took were: 'Two tall pillars made out of bright *zahalu* metal, which weighed 2,500 talents; the fixtures I tore up from their fittings and took to Assyria' (Budge 1926: 39). These two small pillars were probably small obelisks. It is interesting to calculate their value: he says they weighed 2,500 talents, which is equivalent to about 2.5 tonnes (49 hundredweight), or 5,000 pounds troy. If they were of solid gold, then the value would be at least several million pounds by today's reckoning.

The obelisks caught the attention of Western civilizations when the Greeks conquered Egypt. The Greeks, and later the Romans, were

fascinated by the power and authority that seemed to be imbued in these colossal monuments. This contact would eventually see, as a consequence, the most movable obelisks finding their way to the West.

CHAPTER 3

CONTACT WITH THE WEST
GREECE AND ROME

As far back as Homeric times, Egypt had been known to the Greeks as a region of fabulous wealth. Its fame—even when it was in decline—is noted in the *Iliad*: 'Where in Egyptian Thebes, where the houses overflow with the greatest troves of treasure . . . Thebes with the hundred gates and through each gate battalions, two hundred fighters, surge to war with teams and chariots . . .' (Homer *Iliad* 9: 467–9).

When the Greeks arrived in Egypt and saw the huge free-standing stones they gave them the name by which they are known today. The word 'obelisk' derives from *obelos*, the Greek for a meat skewer. It appears the Greeks tended to use words associated with food to describe the different monuments they discovered during their travels, the word 'pyramid' also comes from the Greek word for little honey cakes, no doubt because of the similarity in shape.

Herodotus allegedly visited Egypt in the fifth century BC. He wrote of the region and its customs and especially its religion, which he compared to Greek religion. Herodotus also gives us information on the construction and removal of the massive blocks of stone. He records the transportation of the huge granite shrine at Saïs, which he himself witnessed, and so provides us with some insight into how these monuments were constructed:

> But what caused me more astonishment than anything else was a room hollowed from a single block of stone; this block also came from Elephantine and took three years to bring to

Saïs, two thousand men, all of the pilot class, having the task of conveying it. The outside measurements of this chamber are: length 21 cubits [9.5m; 31½ft]; breadth 14 cubits [6m; 22ft]; height, 8 cubits [3.6m; 12ft]. (Herodotus *Histories* 2: 175)

Herodotus also tells us about the benu bird. During the early dynastic period (2920–2575 BC), the Egyptians believed that a stone was the abode of the sun, which, at the dawn of creation, made itself visible at the top of the stone by emerging as a bird. The bird was called the 'benu' and was regarded as the reincarnation of the soul of Rā and the heart of Osiris. According to some Egyptian texts, it appeared each morning on the sacred Persea tree of Anu. From early times the bird had its own temple dedicated to it, called He-t Benu.

Later, the Greeks identified the benu bird with the mythical phoenix; stories concerning this bird and its origins can be found not only in the writings of Herodotus but also the works of the second-century AD Roman historian Tacitus. Herodotus gives us this account of the origins of the phoenix:

For I have not seen a phoenix myself, it is very rare and visits the country (so at least they say at Heliopolis) only at intervals of 500 years, on the occasion of the death of the parent bird . . .

Here is a story about the phoenix: it brings its parent a lump of myrrh all the way from Arabia, and buries the body in the temple of the sun. To perform this feat, the bird first shapes some myrrh into a sort of egg as big as it finds, by testing, that it can carry; then it hollows the lump out, puts its father inside and smears some more myrrh over the hole. The egg-shaped lump is then just of the same weight as it was originally. Finally it is carried by the bird to the temple of the sun in Egypt. Such at least is the story. (Herodotus *Histories* 2: 73)

Tacitus gives a slightly more detailed account of the mythical bird:

> The phoenix is sacred to the sun. Those who depicted it agree that its head and the markings of its plumage distinguish it from other birds. Regarding the length of its life, accounts vary. The commonest view favours 500 years. But some estimate that it appears every 1,461 years, and that the three last seen flew to Heliopolis in the reigns of Sesosis, Amasis and Ptolemy III (of the Macedonian dynasty) respectively.

He continues:

> For when its years are complete and death is close, it is said to make a nest in its own country and shed over it a procreative substance, from which it rises as a young phoenix. Its first function after growth is the burial of its father. This is habitually done as follows. After proving, by a long flight with a load of myrrh, that it is capable of the burden and the journey, it takes up its father's body and carries it to the altar of the sun and burns it. The details are disputed and embellished by myths. But that the bird sometimes appears in Egypt is unquestioned. (Tacitus *Annals* 6: 28)

The earlier Roman author, Pliny the Elder (AD 29–73), in his *Natural History* (10: 2) tells us that only one phoenix bird lived at any one time and that its successor developed from a worm that crawled out of the deceased bird, under the influence of the sun. It seems that Tacitus had not consulted Pliny's account, but, nevertheless, these ancient accounts provide a wealth of useful information on Egyptian belief and practice.

On the death of Alexander the Great in 323 BC, Egypt began a new era under the rule of Alexander's general, Ptolemy. Up to this point Egypt had been part of the Persian Empire, but Alexander gained control of it without much opposition. Alexander stayed in Egypt

for a year, during which he visited the temple at Siwa and founded the city of Alexandria on the Mediterranean coast.

The royal line established by the Ptolemies lasted for four centuries and saw considerable expansion at home and abroad. The city of Alexandria became the capital, replacing Memphis, and was one of the greatest cities of the ancient world. Greek immigration began in earnest and spread Hellenic culture throughout Egypt. Ptolemaic rule brought innovations to Egypt, but traditional customs from the past also continued, especially in the realms of administration, religion and architecture.

The second century of Ptolemaic rule was one of decline and revolts. Soon Rome, the rising power in the Mediterranean, began to intervene, and in 168 BC Egypt became a Roman protectorate. In 58 BC Egypt was the setting for the civil wars that were now tearing apart the Roman Republic, and Rome annexed the Ptolemaic kingdom of Cyprus. After years of exile, Ptolemy XII died in 51 BC, leaving his kingdom to his children, Cleopatra VII and her younger brother Ptolemy XIII. In 49 BC they began waging war against one another.

In 48 BC, after his defeat by Julius Caesar at the Battle of Pharsalus, the Roman general Pompey fled to Egypt, where he was killed on the orders of the young Ptolemy XIII. Caesar entered Alexandria and was besieged by Ptolemy, but he gained victory and Ptolemy was killed. Caesar now allied himself with Cleopatra; together they had a son, Caesarion, and Cleopatra followed him to Rome, where she lived until his assassination in 44 BC.

Between them, they had planned to forge a mighty empire like that of Cleopatra's ancestor, Alexander. The fusion of the ideals of Hellenistic monarchy with the constraints of Republican Rome would eventually come to pass, but it would be the Roman Empire that would engender it, under the leadership of one man, Octavian, the future emperor Augustus.

CHAPTER 4

ROMAN ANNEXATION OF EGYPT

The story of the Egyptian obelisks' travels to the West begins on 2 September 31 BC, when a minor naval skirmish in the Gulf of Ambracia off the north-western coast of Greece altered the course of history for the Western world. The main protagonists were Mark Antony, the Roman general who had once been a close friend of Julius Caesar, along with his consort Cleopatra VII of Egypt—the last of the Ptolemaic dynasty—and the young inexperienced nephew and adoptive son of Julius Caesar, Octavian. Since the assassination of Julius Caesar in 44 BC, the main rivalry for control of the Roman world had been played out between Octavian and Antony.

In 31 BC Antony embarked on a foolhardy naval expedition, instead of choosing to meet Octavian on land, where Antony had far superior forces. It was only with Cleopatra's wealth and resources that Antony had the means to withstand Octavian, but he knew that, if he wanted to rule in Rome, he could not do so in association with the oriental despotism so hated by the Romans. As long as Cleopatra was seen as co-leader of the campaign, Antony could not invade Italy; if he were to do so his generals and army might well fall away. He had to force Octavian to attack him and thus move the theatre of war outside Italy.

By January 31 BC, Octavian had embarked on his third term as consul, the highest office in Republican Rome, a position that the Senate had chosen him to co-hold with Antony. However, Octavian now held the government of the West so firmly in his grasp that he was able to influence the Senate, and intervened to remove Antony, thus barring him from the consulship.

According to legend, before the battle, Octavian went in solemn procession to the shrine of Bellona, personification of battle frenzy, which was situated to the east of the temple of Apollo. This temple had been consecrated by Appis Claudius Caecus in 296 BC during the battle against the Samnites and Etruscans and so bore a special connection to the Claudian family. As Octavian was married to the Claudian Livia, it thus also had significance for the Julian family of Octavian. Outside the shrine, on the Campus Martius (Field of Mars), Octavian allegedly hurled a blood-tipped spear in the direction of his enemy, Egypt, and declared a just war (*justum bellum*) against Cleopatra VII. By this means of subtle propaganda he removed any suggestion that this was merely another episode in the long-running civil war; instead it appeared as a direct patriotic response to a threatened invasion by an oriental queen.

The Battle of Actium was short: by 4 p.m. that day Antony's fleet had surrendered. The story of Antony's flight from the battle with Cleopatra is the stuff of drama and Hollywood films. Octavian did not pursue the defeated Antony; he gave the couple almost a year's grace, mainly because he had problems that needed his attention back in Rome. Renewed attempts to find land for discharged veterans, and the general impoverishment resulting from years of war, had led to many severe internal disturbances. Octavian had to return to Rome to stem the tide of potential revolution with immediate payouts and many promises of future ones. He knew he would need money, and quite a lot of it; so in 30 BC he made his way east, eyes firmly fixed on the rich prize of Egypt.

By this time, Antony had taken refuge in Alexandria and was little threat to Octavian. His troops had deserted him and he was a broken man, spending his days and nights in drunken revelries with his queen, Cleopatra. She, on the other hand, was still inclined to make some deal with Octavian, if not for her sake then for the sake of her four children: her son by Caesar (Caesarion), and her two sons and daughter by Mark Antony. She sent a delegation to Octavian in Syria, offering to surrender her crown on condition that her children could inherit the Egyptian throne. For his part, Antony

would surrender all rank and authority and asked only to exist as a private citizen, if not in Alexandria then in Athens. Octavian replied that he would grant Cleopatra any reasonable request she might make, provided she either executed Antony or banished him from Egypt. Cleopatra thus had the measure of Octavian: his real desire was for the wealth of Egypt, so she refused to give up Antony.

In July 30 BC Octavian marched into Egypt, quickly over-running Pelusium, and arriving on the outskirts of Alexandria on the last day of the month. Octavian refused Antony's call to meet him in single combat. Outnumbered and desperate, Antony committed suicide, dying in the mausoleum built for Cleopatra. Later that same day, 1 August, Octavian entered Alexandria, where he was informed of Antony's death.

Within days he sent for Cleopatra. In many ways they were similar and both were certainly politically astute. She knew that Rome now held everything and there was no guarantee that her children would be allowed to rule after her. The details of the meeting between Octavian and Cleopatra are not recorded, but the Greek historian Plutarch (AD 46–120) wrote that Octavian left Cleopatra, 'believing that he had deceived her, but he himself was deceived'. He had already made arrangements for her and her children to be deported from Egypt, but he granted her request to pour a last libation to Antony. Cleopatra went to the mausoleum and, after preparing herself, died by the bite of an asp.

The death of Cleopatra and the possession of her Egyptian wealth saved Octavian. When these riches arrived in Rome, the rate of interest dropped from a staggering 12 per cent to 4 per cent. Octavian was now able to make good the promises he had earlier made to the discharged veterans, and at the same time still have enough left over for spectacular new public works. Approximately 120,000 veterans were given 1,000 sesterces each, while the people of Rome each received 400 sesterces.

The triumph of Octavian brought the age of civil wars to an end; yet one victory was denied him—the capture of Cleopatra and her appearance in his triumphal procession. The victory over Egypt

secured him the title of the first citizen (*princeps civitatis*). In return for peace and security, Rome gave up its republican freedoms and embarked on a new regime, the principate, guided and directed by Octavian, now known as Augustus Caesar, emperor of Rome.

The success of the principate depended initially on the economic strength of Egypt. Within a few years of Cleopatra's death Egypt began to send Rome some five million bushels of grain a year, about a third of Rome's total consumption. There were many other financial benefits from Egypt's geographical position at the centre of trade routes between the Mediterranean, Africa and India. These riches were an immeasurable prize, and Augustus never relinquished them.

Although a province—apparently like any other in the empire— Egypt was also the personal estate of the emperor; no senator could even visit it without the express permission of Augustus. He managed to establish in Egypt a form of kingship that was every bit as regal as that of the Ptolemaic dynasty and its last representative, Cleopatra. Egypt easily assimilated Augustus into the line of the pharaohs and the Ptolemies, and, like them he was a god king.

Augustus erected obelisks at the Caesarium in honour of his adoptive father Julius Caesar. The Caesarium was a temple originally built in Alexandria by Cleopatra in honour of Mark Antony and of the deified Julius Caesar, of which more will be said later. Augustus also built a temple at Kalabasha, which came to be called the 'Karnak of Nubia' because of its vast size. On the walls are cartouches showing Augustus and his adoptive son, the future emperor Tiberius, as pharaohs. Augustus was far too shrewd to see himself as divine, something that would not have been acceptable in Rome, but he wished to establish a monarchical rule in Egypt. By the subtle use of Egyptian images and practices he managed to establish a divine right of kingship that would influence the Western world for centuries.

CHAPTER 5

EGYPTIAN INFLUENCES IN ROME

E ven before Octavian's victory at Actium, earlier contact with Egypt during the period of the republic had resulted in a migration of Egyptian religious ideologies, including the cult of Isis and the practice of astrology, which would later exert a profound effect on emperors and civilians alike. It is important to say something about these influences, to demonstrate the effect that the ideology encompassed by the obelisks was later to have.

The Cult of Isis and Serapis

Less visible, but no less important than the obelisks, was the adoption by many Romans during the first century BC of the Hellenized Egyptian cult of Isis. By the end of the Ptolemaic period, the religious triad of Osiris, god of the dead, his consort Isis and their son Horus could be found throughout the Classical world. The cult of Osiris became increasingly popular, as did that of Isis, whose magic was responsible for Osiris's resurrection and, with the aid of her son, for avenging his death.

However, the Roman version was not the same as the original Egyptian cult but an amalgam of Egyptian and Hellenistic religions. As Turcan says, 'It seems that the Ptolemies strove to reconcile the Nilotic tradition with Hellenic piety by instituting the cult of Serapis' (1996: 76). The cult of Serapis possibly dates to Ptolemy I Soter or Ptolemy II Philadelphia (305–246 BC) and is submerged in confusing and often contradictory legends.

According to Plutarch (*Isis and Osiris* 28), Ptolemy I dreamed he saw Pluto, god of the underworld (Tacitus says it was a 'young man',

Histories 4: 83, 1), who summoned him to seek him out at Sinope in Pontus. Even this apparently simple tale is full of resonances: in Egyptian '*Sen-Hapi*' means 'dwelling place of Apis' (Apis is the bull cult), and Sinopion is the name of a hill where the cult of Apis and Osor-Hapi had developed long before the Macedonian Ptolemies had arrived in Egypt. We can thus clearly see a fusion of the Egyptian cult of Osor-Hapi with the Greek Pluto, king of the underworld. The Serapeum of Alexandria, erected by Ptolemy III (246–221 BC) in honour of Isis and Serapis, became one of the most important sanctuaries in the ancient world.

With the annexation of Egypt by Rome the cult of Isis and Serapis began to spread rapidly throughout the empire, and was modified by the addition of other, Greek, cults. During the first three decades of the first century BC the cult had made some impact in Rome. It was not permitted within the sacred *pomerium* (the boundary of the city where soldiers had to lay aside their weapons), but statues and altars had been erected on the Capitol before 58 BC, which the Senate had ordered to be destroyed. The followers of the cult erected private chapels without official authorization, which the Senate once again demolished in 53 BC. By October 43 BC, though, the devotees of the cult were fairly numerous and the triumvirs Lepidus, Antony and Octavian, anxious to have their support, decided to have a temple built in honour of Isis and Serapis.

Events overtook the promise, though, and the temple did not materialize. With the defeat of Antony (who had represented himself as the reincarnation of Osiris) and Cleopatra (self-styled New Isis) at Actium, the cult in Rome remained purely a private affair, for political as well as religious reasons. Ironically, during the later proscriptions of the triumvirs, the aedile M. Volusius donned the jackal-headed mask of Anubis and the linen clothes of the Isiac devotees in order to escape persecution. Valerius Maximus commented: 'Can there be anything more deplorable than a Roman magistrate having to disguise himself in the trappings of a foreign religion?' (*Memorabilia* 7: 3, 8).

In 21 BC, while Augustus was away in Sicily, trouble broke out in Rome and was swiftly dealt with by his son-in-law, Marcus Agrippa, who restored order and, according to Cassius Dio, drove from the *pomerium* the Egyptian cults 'which were again invading the city' (*History* 54: 6, 6). The cults were banned from the suburbs for a radius of seven and a half stadia (1.33km; 0.8 mile) of the *urbs*.

Despite these restrictions, the palaces of the emperor and his immediate family show a certain 'Egyptomania'. For example, in the house of Augustus' wife Livia there were wall paintings that showed the signs of what Turcan calls an 'Egyptianising solar theology' (1996: 89). In part of Augustus' residence on the Palatine, the Aula Isiaca (dated to the 20s BC), similar Egyptian motifs could also be found. Furthermore, in the adjoining temple of the Palatine Apollo, terracotta plaques showing Isis between two sphinxes were discovered. It can hardly be unconnected that Augustus used the sphinx, seen as a symbol of hope, as his seal; the same emblem also appears on Roman eastern coinage after Actium.

During the reign of Augustus' successor, his stepson Tiberius, the cult of Isis fared less well. Suetonius (*Tiberius* 36: 1) tells us that Tiberius banned Egyptian rites from Rome, forcing the priests to burn their religious vestments and other religious paraphernalia. In AD 19 they were deported (along with the Jews, who numbered a total of 4,000 freedmen) to Sardinia.

At roughly the same time, a scandal involving the cult occurred. The story is perhaps exaggerated but worth repeating. The first-century historian Josephus tells us that a knight, Decius Mundus, was smitten by a beautiful aristocratic lady called Paulina. However, she rejected him and the 200,000 drachmae he offered for just one night of passion with her. Mundus' freedwoman Ida, eager to make some money for herself, devised a plan: she knew that Paulina was a devotee of Isis, so she arranged for the priests to receive 250,000 drachmae if they helped facilitate her scheme. One of the priests went to Paulina's house and said that he had received a message

from Anubis, the jackal-headed god, that he wished her to visit the sanctuary because he had been 'conquered by love'. She told her husband, who trusted her and allowed her to go. When Paulina arrived at the designated hour, the doors to the sanctuary were locked behind her, and Mundus, disguised as Anubis, 'was not rebuffed when he sought intercourse with her' (Josephus *Jewish Antiquities* 17: 70–3). So Paulina spent the night there servicing her god. All would have been well, had not Mundus revealed his trick the next time he met Paulina. She immediately rushed to her husband and confessed what had happened. The husband denounced Mundus to Tiberius, who promptly had the freewoman Ida crucified, the temple of Isis razed to the ground and the idol thrown in the Tiber; Mundus was merely exiled.

A Pyramid in Rome

The Romans' fascination with all things Egyptian can be seen in the most identifiably Egyptian monument to have appeared in Rome during the first century BC: the Pyramid of Cestius. This is a monumental tomb built during the reign of Augustus between the years 18 BC and 12 BC. According to the inscription on the east side of the monument, it was erected in 330 days at the fork of the Via Ostiensis, and a road that ran across to the Tiber (roughly where the Via della Marmorata is now). Its dedicatory inscription, repeated on the west and east sides so as to be visible from both roads, declares that it was erected by Cestius. On the west side the inscription says:

> C.CESTIVS L F POB. EPVLO PR TR PL/ VII VIR
> EPVLONVM.

Gaius Cestius Epulo, son of Lucius, of the voting tribe Poblilia, praetor [magistrate], tribune of the *plebs*, one of seven state priests in charge of public banquets (*epulones*) in honour of Jupiter [and other religious festivals]

On the east side is a smaller inscription beneath the dedicatory one, recording that the tomb was built in accordance with Cestius' will by his relatives:

(OPVS APSOLVTVM EX TESTAMENTO DIEBVS CCCXXX/ ARBITRATV/ PONTI P F CLA MELAE HEREDIS ET POTHI L (F)).

The work was completed, in accordance with the will, in 300 days, under the direction of the heir [Lucius] Pontus Mela, son of Publius of the Claudia tribe, and of Pothus the freedman.

The tomb was constructed of concrete, faced with blocks of white Italian marble and measured 30 metres (96ft) square at the base and standing 34.5 metres (113ft) high. Parallels of this tomb, built for private individuals, can be found in Upper Egypt and were characteristic of the New Kingdom. By Cestius' time they were extremely common in Nubia (Sudan); Egypt had been annexed as a province in 24 BC, which might suggest that Cestius had served there and been inspired by the monuments he saw. It is possible that he was an ancestor of Aelius Gallus, who was the one of the first Roman governors of the province in AD 20.

Excavations carried out on the western side of the pyramid in 1663 found two marble bases for bronze statues with accompanying inscriptions. These stated that they were set up by Cestius' heirs, one of whom was Marcus Agrippa (the son-in-law of Augustus), and paid for by the sale of valuable tapestries (*attalici*), which could not be deposited in the tomb because of recent legislation against luxury. The excavations also revealed two columns, now re-erected in their original position at the corners of the base of the pyramid on the west side, and the tunnel leading into the funerary chamber. The contents had been stolen in antiquity but the wall paintings were still visible. In the late third century AD when the Aurelianic city walls were built, the pyramid was incorporated on its diagonal so as to form a triangular bastion. Cestius' tomb was not unique:

apparently there was another, demolished during the fifteenth or sixteenth century, that had stood between the Vatican and the Mausoleum of Hadrian.

Early in the principate, Augustus had been in a precarious position and fighting for recognition of his position. One way that he could achieve this was by the subtle use of the ancient eastern art of astrology. Diodorus of Sicily, writing between 60 BC and 30 BC, tells us that Egypt was the established home of astrology at this time, but it emerged in Rome as the old republic collapsed. In the first century BC, astrology became associated with aristocratic leaders such as Sulla, Pompey and Caesar—the generals who had taken the extreme step of marching on Rome. Under the old republican system, power was diffused among a small ruling class, and religious diviners were under state control. As Tamsyn Barton remarks, though, astrology is closely linked with monarchy, and so: 'the astrologer with his individual predications is a sign of the political shifts which had taken place' (1994: 41). In this way, it can surely be no coincidence that astrology emerged in Rome at this time, as it was under the control of the sole ruler, just as state diviners had belonged to the republic.

There is evidence to indicate that Augustus was very familiar with astrological practices. The Roman historian Suetonius relates that, at Apollonia in Greece, Augustus and Agrippa visited Theogenes the astrologer to consult him about their respective futures.

> Agrippa went first and was prophesied such almost incredibly good fortune that Augustus expected a far less encouraging response, and felt ashamed to disclose the time of his birth. Yet when at last, after a great deal of hesitation, he grudgingly supplied the information for which both were pressing him, Theogenes rose and flung himself at his [Augustus'] feet and gave Augustus such an implicit faith in his destiny that he ventured to publish his horoscope, and struck a silver coin stamped with Capricorn, the sign under which he had been born. (Suetonius *Augustus* 94–5)

The third-century AD historian Cassius Dio backs up these references made by Suetonius, and adds that Augustus had his horoscope published as an edict, which lends weight to the importance that Augustus placed upon astrology. The official claim that his destiny was outlined in the stars was a 'profoundly monarchical action' (Barton 1994: 41), and in direct contradiction to his claims of restoring the republic. However, when Augustus chose astrology to legitimize his position, he was setting a very dangerous precedent. At the end of his life he was most probably aware of this and issued a decree that forbade private consultations.

Unfortunately, the stage had been set, and during the reign of the next emperor, Tiberius (AD 14–37), astrology was often linked with treason in the many trials that marked his reign. The stories concerning Tiberius' use of astrology confirmed the idea of astrology's infallibility and laid the pattern for future emperors, who tried—with varying success—to regulate its practice by law.

Further hard evidence about Augustus' reliance on astrology to legitimize his position can be found in surviving archaeological material. Not only are there large numbers of coins with the Capricorn motif mentioned by Suetonius, but there are also sculptural reliefs, terracottas, paintings and jewellery with the symbol. Even simple roof tiles show Victoria (goddess of Victory) linked with Capricorn. Clearly, Augustus made Capricorn his personal badge and linked it with a number of other themes as part of his image making.

The Capricorn symbol carried a number of connotations, mainly associated with a new era, as it was the sign in which the sun began to rise again after the winter solstice. Augustus further exploited his links with the Graeco-Roman god Apollo, the god associated with the sun. On the breastplate of the statue of Augustus from Prima Porta, was Sol the sun god in his chariot, appearing above Apollo, signifying the cosmic representation of the new ideology of victory.

* * *

After the pyramids, the most visually striking monuments Egypt had to offer were the obelisks. At first sight one might assume that these monuments were removed by Augustus as victory trophies, but two obelisks in particular indicate that he may have employed them to justify his right to rule, and possibly his right to establish a dynasty.

CHAPTER 6

AUGUSTUS AND THE FIRST EGYPTIAN OBELISKS TO REACH ROME

We know from the accounts of the first-century AD Roman writer, Pliny the Elder, that Augustus brought several obelisks to Rome sometime between 13 BC and 10 BC, to mark the twentieth anniversary of the conquest of Egypt. Two in particular (**1, 2**) are given special attention here because of the significant role they played in establishing Augustus' right to rule.

The siting of these monuments was very important, and the Campus Martius (Field of Mars), was the selected location. It was a flat piece of land originally used for military training, with areas set aside for horse and chariot racing. It was also used for public meetings and voting and was the place where the five-year census was taken. By the time of Augustus, the area had undergone several redevelopments: many new buildings had been added, including temples, porticos and a theatre. To the Roman people, the Campus Martius was the central meeting place, the heart of the city, and it contained temples to the major deities.

The first obelisk (which later became the Montecitorio obelisk, **1**) that was re-erected in the Campus Martius was sited near to the Altar of Peace (Ara Pacis) that the Senate had voted to build on Augustus' return from Spain and Gaul in 13 BC. Peace reigned throughout the empire; as Augustus modestly pointed out in his *Res Gestae*, this had previously occurred only twice in Roman history, but in his reign there were three periods of such peace (*Res Gestae* 13).

The altar was close to the Mausoleum—Augustus' tomb, built in 28 BC—which was the largest ever built in Rome up to that time, and which may have been dedicated by Augustus to Sol, the sun god. The dedication to Sol may be significant: the sun god comes into greater prominence at the same time as individual rule. Mark Antony depicted the god on his coins, so it was singularly fitting that Augustus should make the dedication to Sol to subtly emphasize his victory over Antony.

The powerful message conveyed by the proximity of the Altar of Peace, the Mausoleum and the obelisk reflected Augustan political ideology and the power of the ruling family.

This first obelisk mentioned by Pliny the Elder originally stood in Heliopolis, and had been set up there by Psammetichus II, king of Egypt (593–588 BC). However, it is not known whether it was still standing after the Romans had conquered Egypt. On the *pyramidion* is a relief that shows the king in the form of an ape, making an offering to Rā-Her-aakhuti, the great god, lord of heaven. The god is saying to the king, 'I give you life, all serenity, all health and all joy of heart forever.' Above the king is written: 'King of the South and the North, Nefer-ab-Rā son of Rā, Psemmthek living like Rā forever and ever'.

On each side of its *pyramidion* is a winged scarab holding a sun disc, with the shaft below showing scenes of the king in the form of a recumbent sphinx. The hieroglyphs on the north side are completely illegible, but those on the other sides that are preserved repeat the king's relationship to Rā.

The first-century BC Roman inscriptions carved on the pedestal were in Latin and Greek. Today only the Latin inscription remains and reads:

IMP. CAESAR.DIVI.F
AVGVSTVS
PONTIFEX. MAXIMVS
IMP.XII.COS.XI.TRIB.POT.XIV

AEGYPTO. IN. POTESTATEM
POPVLI.ROMANI.REDACTA
SOLI.DONVM.DEDIT

Caesar, emperor, son of the deified Julius, Augustus, chief priest, imperator for the twelfth time, consul for the eleventh, holder of tribunician power for the fourteenth time, [10 BC]. Egypt having been brought under the rule of the Roman people, he gave this as a gift to Sol [the sun god].

The inscription was later added to by Pope Pius VI in 1792 when the obelisk was re-erected in the Piazza di Montecitorio (see below).

Pliny tells us the obelisk was used as a sundial or *gnomon* (needle), and that it:

> marked the shadows projected by the sun, and so measuring the length of the days and nights. With this object, a stone monument was laid, the extreme length of which corresponded exactly with the length of the shadow thrown by the obelisk at the sixth hour [noon] on the day of the winter solstice. After this period the shadow would go on day by day, gradually decreasing, and then again would as gradually increase, correspondingly with certain lines of brass that were inserted in the stone. (Pliny *Natural History* 36: 15)

The dial, created and designed by the mathematician Novius Facundus, was inlaid in bronze on a vast expanse of travertine paving on the north side of the obelisk's shaft, over which the obelisk cast a shadow up to 30 metres (99ft) long (see Fig. 3). The lines were marked by strips of bronze inlaid in the marble and indicated midday at various seasons of the year. Pliny writes that Facundus placed a gilded ball on the top of the obelisk in order that, 'the shadow of the summit might be condensed and agglomerated, so preventing the shadow of the apex from running to a fine point of enormous extent'; Facundus, so Pliny says, got the idea from the shadow projected by the human head.

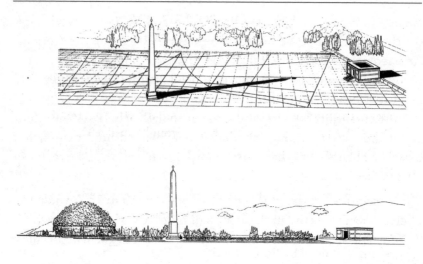

3 Augustus' sundial obelisk, sited close to the Ara Pacis and Mausoleum

When Pliny wrote about the sundial, approximately seventy years after its erection by Augustus, it had not been functioning properly for almost thirty years, despite the fact the obelisk had, according to Pliny, foundations that were 'sunk as deep into the earth as the obelisk was high'. The pointer had probably shifted off mark and Pliny gives a variety of reasons why this could have happened, ranging from celestial upheavals to earthquakes. It is certainly likely that the foundations could have shifted, or perhaps it had not worked properly from the start. In the late 70s or 80s AD, after the general ground level was raised over a metre, at least the central part of the dial was re-laid.

A short section of the meridian line was discovered at the higher level by a team of German excavators between 1979 and 1980. The cross-bars and signs of the zodiac written alongside them in Greek show how the meridian also functioned as a calendar, indicating the day of the month by the precise length of the shadow cast at noon; the smaller Greek annotations say that the trade winds stop before Virgo and summer begins during Taurus. Only one other part of the dial floor has ever been recorded, and that was in 1463 when

foundations for the Chapel of St Philip and St James were sunk on the west side of St Lorenzo. Professor Rakob of the German Archaeological Institute calculated that the sundial would have required a space of 60 x 75 metres (65 x 82 yards) to work correctly as a calendar.

The Roman author Vitruvius wrote in Book IX of his *De Architectura* about the construction of sundials. He explained how a sundial is based on shadow lengths measured five hours before and five hours after noon. Vitruvius also recorded that a Babylonian priest named Berossus, who settled on the island of Cos and established a school of astrology there, was also credited with inventing a particular type of sundial based on astrological calculations, which may also be the type of sundial used by Facundus.

In the 1990s, following Vitruvius' advice for sundial construction, the American archaeologist Thayer calculated that the pavement of Augustus' sundial would have had to be a semi-ellipse with an east–west major axis 436 metres (475 yards) long with the obelisk at the midpoint, and a semi minor axis (northwards only from the obelisk) of 50 metres (55 yards). This would need a huge piazza to accommodate it (by way of comparison, the main part of the St Peter's Square is an ellipse whose major axis measures 240 metres (262 yards) or, alternatively it would need to cover about ten US football fields). If this is the case, then the east–west dimensions Pliny gives us suggest that the timepiece would only be useful for half the daylight hours.

This raises the question that perhaps the obelisk was intended solely for purposes of propaganda by Augustus. The historian Werner Eck says: 'Augustus intended his rule to go down in history as the *pax Augusta* [Augustan peace]' (2003: 93), and it was no doubt significant that the sundial was so positioned that the *gnomon* cast its shadow onto the nearby Altar of Peace on Augustus' birthday (23 September), suggesting that his reign of peace was predestined at his birth. Augustus' birth, destiny and achievements could thus be rendered visible in a single moment; even the gods of Egypt, so it appeared, sanctioned his divine right to rule.

* * *

The sundial obelisk remained an integral part of the landscape until sometime between the tenth and eleventh centuries AD, when it fell down and broke into five pieces, perhaps as a result of a fire. It was found by a barber digging a latrine near the Church of St Lorenzo during the time of Pope Julius II (1503–13). It remained buried— but not forgotten—until 1585, when a resurgence of interest was taken in the obelisks of Rome by Pope Sixtus V (1585–86).

Because, according to Sixtus, this obelisk had once been 'of astronomical interest', he took special care in trying to relocate it. Sixtus decided to commission a bronze globe with holes in it to be placed on the top, so that a ray of light crossing the globe would reach a number of notches on the pavement (which can still be seen in Montecitorio). This was intended to make the obelisk work as a sundial once more. Sixtus ordered it to be re-erected in March 1587, but on further examination its condition was so poor that later the same month it was reburied instead.

Pope Alexander VII (1655–67) also tried to re-erect the obelisk but he was similarly unable to deal with the problems it posed. However, the attempts by Pope Benedict XIV (1740–58) proved more successful. In April 1748 the obelisk was finally removed from the square, which had now become surrounded by derelict houses. The discovery was considered so important at the time that a systematic archaeological record was kept. A bronze plaque was fixed to one of the new buildings near to the site, Piazza del Parlamento no. 3, (the Italian Houses of Parliament) to record the event.

Red Aswan granite had to be found to restore the base and the shaft of the obelisk. The pieces used came from the column of the Emperor Antoninus Pius (AD 138–61), which had once stood in the Campus Martius. The column had been erected in memory of him by his adopted sons, Marcus Aurelius and Lucius Verus. It had a 15-metre (50ft) shaft of red Aswan granite, quarried originally by the Emperor Trajan in AD 106 for one of his great building projects but never used. The richly sculpted pedestal to the column

was also excavated and placed in the Vatican Museum. The front of the pedestal shows Antoninus Pius and his wife, Faustina (who pre-deceased him by twenty years), being carried heavenwards by a winged figure, with Roma waving them off from the bottom right, and the personification of the Field of Mars reclining at the left, holding the sundial obelisk to set the scene. The presence of the sundial here reflects the importance that was still attached to the obelisk in successive centuries by later emperors.

Finally, after three years' hard work, on 14 June 1792, the obelisk and its base were set up in the Piazza di Montecitorio by Pius VI. A Latin inscription was added to the original inscription, telling the story of the obelisk's discovery, mentioning the people involved in its re-erection especially the architect, Antinori:

PIVS VI.PONT.MAX
OBELISCVM REGIS SESOTRIDIS
A. C. CAESARE AVGVSTVO HORARVM
INDICEM IN CAMPO STATVM
QVEM IGNIS VI ET TEMPORVM
VETVSTATE CORRVPTVM BENEDICTVS XIV
P.M. EX AGGESTA HVMO
AMOLITVM RELIQVERAT SQVALORE
DETERSO CVLTVQVE ADDITI VRBI
COELOQVE RESTITVIT
ANNO M.DCCXCII
SACRI PRINCIPATVS EIVS XVIII.

Pius VI Pontifex Maximus place in the Campus the obelisk of King Sesotris, erected by Caius Augustus Caesar as the hours' indicator, which by the force of fire and time's ageing had been corrupted. Benedict XIV Pontifex Maximus removed the piled up soil and washed off the dirt and with care and added it to the city and sky in the year 1792, the eighteenth year of his holy principate.

The only minor discrepancy in the inscription is that Pius VI attributes the obelisk to the pharaoh Sesostris, instead of Psammetichus II.

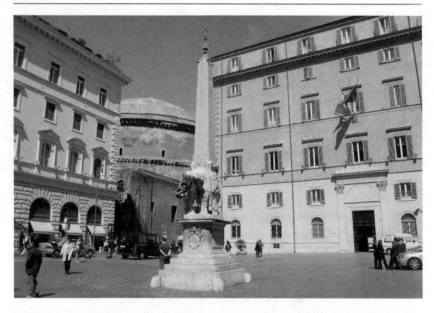

*4 Piazza di Montecitorio: Augustus' obelisk (**1**)*

* * *

In the 1960s the obelisk was again in danger of collapse because the original blocks used to restore it were shifting from their position. The necessary repairs were made in 1965 and the obelisk now stands in the square in front of the Italian Houses of Parliament.

This was not the only obelisk erected in Rome by Augustus, yet it is the most identifiable from the accounts of Pliny because of the use to which it was put. It appears that Augustus brought at least four obelisks to Rome but there could be more that have since become identified with later emperors.

CHAPTER 7

OTHER AUGUSTAN OBELISKS

The Flaminian Obelisk (Piazza del Popolo) (2)

Augustus re-erected a second obelisk (**2**) in the Campus Martius, this one in the Circus Flaminius (the southern sector of the Campus Martius, where chariot and horse racing took place) at the east end of the *spina*, the richly ornamented central barrier around which the racetrack turned. It was erected at the same time as the sundial obelisk in the Campus Martius (**1**); archaeologists have ascertained this because the inscriptions are identical to those on the base of Psammetichus' obelisk (see *Corpus Inscriptiorum Latinum* vi 701 = 702 for the full text). The Circus Maximus was close to the Flaminian Way, from which the obelisk got its current name.

The Flaminian obelisk was originally set up by the pharaoh Seti I at Heliopolis, around 1300 BC. It is almost 24 metres (78ft) high and weighs approximately 235 tonnes. The shaft had been partly inscribed during Seti's lifetime, but at his death the eastern side was without an inscription. Seti had copied the arrangement of the text on older obelisks, placing just one column of hieroglyphs on each of the three faces. His son and successor, Ramses II, completed the monument, adding two columns of hieroglyphs on each of these three faces and three columns on the previously uninscribed face. On three sides of the *pyramidion* are cut vignettes on which Seti, in the form of a sphinx, is offering a figure of the goddess of truth (Maāt) to the sun god Rā; on the fourth side the king is Ramses II (1290–1224 BC).

In 1842, when archaeologists attempted to decipher the inscriptions, they misread the names of the kings. Although they

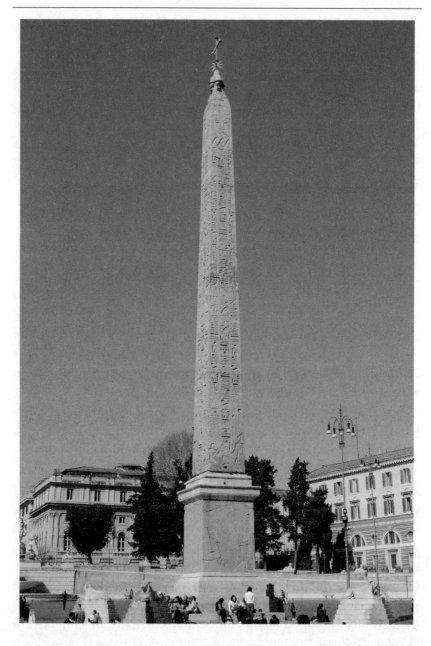

5 *Obelisk of Augustus/Seti I in Piazza del Popolo (2)*

understood that two kings were involved in its dedications they believed them to be Mer-en-Ptah and his son, Ramses III (1194– 1163 BC).

There was also some confusion in antiquity regarding the translation of the hieroglyphs. The Roman historian Ammianus Marcellinus (c.AD 325–395) tells us that an Egyptian priest, about whom we know nothing except his name—Hermapion—produced a Greek translation for Augustus (Ammianus *History* 4: 17–18). Hermapion's translation of line 1 on the south side reads:

> The sun to King Ramestes. I have given to you that you should with joy rule over the whole earth, you whom the sun loves ... whom the sun has chosen, the doughty son of Mars, King Ramestes. To him the whole earth is made subject through his valour and boldness. . .

For line 3 he has: '. . . Apollo the mighty son of Heron, Ramestes, King of the World, who has preserved Egypt by conquering other nations . . .'; and for line 1 on the east side: '. . . the ruler over all the earth; whom the sun has chosen . . .'. Ammianus' rendition of part of the Greek inscription, plus a full translation of the hieroglyphic inscription is in the Appendix, allowing comparisons to be made between the two original texts.

This Greek translation of the hieroglyphs—no doubt under the auspices of Augustus himself—published at the time of the obelisk's erection, seems to be intended to deliver propaganda for Augustus' right to rule. It bears little resemblance to the original text yet makes the important connection between Augustus and his patron Apollo, who defeated the Egyptian gods.

Augustus made political use of his connections with Apollo, whom he represented as his patron and protector. He credited Apollo of the island of Leucas, later revered as the Apollo of Actium, with his victory over the gods of Egypt. When lightning struck part of Augustus' public residence, he declared the spot a sacred precinct and erected a temple to Apollo there, the first temple in Rome to be constructed entirely of white Carrara marble. Later, the

Sibylline oracles would be stored there under the cult statue. During the secular games the temple was the focus of the celebration at which Horace's 'Secular Hymn' was sung. This hymn asked for the protection of the Roman people and the ruler on the Palatine Hill: Augustus.

After the fourth century AD no further information is available concerning the fate of this obelisk in Roman times; it is unclear whether it fell down naturally or was vandalized. After its disappearance in antiquity, it was completely lost until the fifteenth century, when Alberti of Camaldoli found fragments of it in the ruins of the Circus Maximus. Sections of the base were uncovered, but it was not until 1586 under Pope Sixtus V that a constructive search was undertaken for all of the remaining pieces.

It was decided that the obelisk should be re-erected in the Piazza del Popolo as a centrepiece to one of the main approaches to the city from which three principal avenues branch off. The damaged section from the bottom of the obelisk's shaft was removed, and Augustus' original dedicatory inscription salvaged and placed on a newly carved pedestal. Finally, in 1589 it was re-erected. Sixtus V had plans to embellish the square further but died before he was able to realize his goal.

Later, Pius VI (1772–99) redesigned the square, although it was a while before his plans could be carried out. The base of the obelisk was enclosed in marble, set around it were figures of lions carved in the Egyptian style, spouting water into basins. This is how the piazza still looks today, making a beautiful backdrop for the obelisk. Since its re-erection in the sixteenth century it has become the third most important one in Rome, after the Vatican obelisk (**5**) and the one in the Piazza San Giovanni in Laterano (**13**), which also had once stood in the Circus Maximus.

Other Candidates

Further obelisks may be associated with Augustus. The red granite obelisk of Hophra (**3**) originally stood in the Temple of Saïs in Lower Egypt. It stands 5.5 metres (18ft) high and weighs about 5 tonnes. There is a column of hieroglyphs on each face, recording that it was dedicated to the goddess Neith of Saïs, and to Tem of Ta-ānkh-t. His name is followed by epithets naming Atum of the land of life, the cemetery of Saïs and Neit She of the Bee temple in Mehnet, foremost of the land of life; all these deities were connected with places at Saïs.

We have no exact information on when or how this obelisk was brought to Rome. It could have been one of the many imported by Augustus that Pliny mentions. According to Pliny, they were grouped in pairs and stood at the entrance to the Iseum, the Temple of Isis. However, this may not have been their original location, given the fact both Augustus and his successor Tiberius seem to have had an aversion to foreign cults. On the other hand, it is highly possible that they were brought over by Augustus to stand at the entrance to his mausoleum, and later in the first century may have been relocated to the Iseum by the Emperor Domitian, who was a patron of this cult.

After Roman times, this obelisk remained buried where it fell, until 1665, when it was unearthed by Dominican friars laying foundations for a new wall around the garden of their church. Pope Alexander VII entrusted the antiquarian Athanasius Kircher with supervising the clearance of the obelisk. It was repaired and re-erected in 1667 by Bernini, who decided to set it up in the Piazza della Minerva, in front of the Church of Santa Maria Sopra Minerva, quite close to its Roman site.

Various designs for the base were considered, and eventually it was decided to place the obelisk on a statue of an elephant standing on a pedestal with four steps. On it were carved Latin inscriptions recording the date of its erection, the pope responsible for it, and an injunction to those who care to admire it: 'Let any beholder of

the carved images of the wisdom of Egypt on the obelisk carried by the elephant, the strongest of beasts, realize that it takes a robust mind to carry solid wisdom.' Alexander VII did not live to see the dedication of the obelisk, which took place on 11 July 1667, exactly three weeks after his death.

This obelisk's companion (**4**) is now in Urbino in central Italy in the Piazza del Rinascimento. It too was retrieved from the ruins of the Iseum during the eighteenth century. The broken pieces were given to Cardinal Alessandro Albani, who donated them to the town of Urbino and had them transported there in 1737.

Fragments of another obelisk not relocated by the popes were found near the site of the Campus Martius and could be the one Pliny describes as being 9 feet shorter than the one of Psammetichus (**1**). This one was believed to have been made by the pharaoh Sesothis and was covered in inscriptions that Pliny says 'interpret the operations of Nature according to the philosophy of the Egyptians'. Later examination of the inscriptions show this was one of a pair made by Ramses II *c.*1300 BC; its companion has yet to be located.

These obelisks might seem at first to have been taken as spoils from Egypt. However, from the employment of one as a sundial, and the manipulation of the meaning of the hieroglyphs upon another, these two obelisks demonstrate how Augustus may have used them, both as proof of the legitimacy of his rule and to sanction the founding of a dynasty based upon pharaonic and Hellenistic ideologies.

The powerful symbolism embodied by the monuments captured the imagination of the people and, later, the more vivid imaginations of some of Augustus' successors. The Egyptian ideology encapsulated in the visual splendour of the obelisks could be seen as a way of establishing this new regime and may indicate Augustus' desire to reconcile the Greek Orient and the West as part of his imperial ambitions. The trend set by Augustus meant that other obelisks would leave Egypt during the successive centuries of the Roman Empire.

CHAPTER 8

AUGUSTUS' SUCCESSORS
TIBERIUS AND CALIGULA

D uring the reign of Augustus' stepson Tiberius there were no attempts to remove any artefacts from Egypt, and even the cult of Isis fared less well. Suetonius (*Tiberius* 36: 1) tells us that Tiberius banned Egyptian rites from Rome, forcing the priests to burn their vestments and other religious paraphernalia. In AD 19, as already mentioned, they were deported to Sardinia. The only Egyptian influence that Tiberius seemed to favour was astrology, something at which he became particularly adept.

Before he became emperor he summoned the astrologer Thrasyllus to enquire about his future and was impressed by the response, for Thrasyllus predicted that he would be Augustus' successor. Then Tiberius put the astrologer to the test and asked him how his own horoscope appeared for the year and especially that day:

> Thrasyllus, after measuring the positions and distances of the stars, hesitated, then showed alarm. The more he looked, the greater his astonishment and fright. Then he cried that a critical and perhaps a fatal emergency was upon him. Tiberius clasped him, commending his divination of peril, and promising that he would escape it. Thrasyllus was admitted among his closest friends, his pronouncements were regarded as oracular. (Tacitus *Annals* 6: 21)

Thrasyllus obviously had had the foresight to realize that Tiberius may have had other plans for him and so pre-empted his designs. This reliance on astrology was a hallmark of many of Tiberius'

actions; most of the numerous treason trials that resulted in the
deaths of considerable numbers of the aristocracy were a direct
result of astrological predictions. The second-century Roman writer
Juvenal tells us that Tiberius surrounded himself with astrologers
in his self-imposed exile on Capri. According to Dio, the astrologers
were tasked with finding men whose birth charts showed a chance
of their becoming emperor, so that they could be exterminated
(Dio Cassius *Histories* 67: 15, 6). Tiberius' preoccupation with such
matters on the home front, together with his aversion to other
Egyptian influences, meant that no monuments were removed
from Egypt during his reign.

Caligula: The Vatican Obelisk (5)

The next emperor, perhaps the most infamous of all, was Augustus'
great-grandson, Gaius Caligula (AD 37–41), a man who was
apparently obsessed with, among other things, oriental ideas and
customs. As if to counter the austere nature of Tiberius' rule, Caligula
brought the cult of Isis and the fascination with Egyptian ideologies
back with a vengeance. The most frequently cited example of his
mania for Egypt is the story of his incest with his sister Drusilla.
Pharaonic and Ptolemaic practice condoned marriage between
siblings to preserve the royal bloodline. However, both Drusilla and
Caligula had made other marriages, so it is hardly likely that he (or
she) was following any particular Egyptian practice.

Josephus tells us that Caligula was a devotee of the cult of Isis.
He says Caligula was initiated into some of its mysteries and that
he enjoyed dressing up in women's clothes and wearing a wig. It is
supposed that this was a reference to his role as a priest of Isis, for
which he would have worn a long robe (although the cross-dressing
could have other less worthy connotations).

It has also been assumed by some scholars that Caligula was
responsible for building the Iseum. According to Barrett (1989:
220), this assumption is based on the fact that it could not have been
built earlier, as Caligula's predecessors, Augustus and Tiberius, both

had an aversion to foreign cults in Rome, exemplified by Tiberius' expulsion of the devotees of Isis. Barrett is of the opinion that the building of the Iseum may not have taken place until the reign of Claudius (AD 43–54). In the light of this, the supporting evidence cited by some scholars for Caligula's building of the Iseum might seem rather flimsy. The supposed Aula Isiaca (Isiac Chapel) incorporated into the substructures of the later Domus Flavia (Flavian Palace, built between AD 81 and 92) on the Palatine contains a long apsidal room on which are wall paintings with symbolic Egyptian motifs, believed to represent Isis or her priestess. It has now been proven that the paintings predate Caligula's reign by half a century and so may not have an Isiac theme, but be simply decorative. What seems most plausible is that, like many other Romans, Caligula was fascinated by all things Egyptian. Pliny the Elder tells us: 'Now, indeed, even men are beginning to wear on their fingers Harpocrates [a Greek adaptation of the Egyptian child god Horus] and figures of Egyptian deities' (*Natural History* 33: 41).

We do know that Caligula busied himself with initiations and celebrated the rites of foreign mysteries, and certainly his chamberlain, the Egyptian Helicon, exerted a strong influence on him. On the day that Caligula died, preparations were in hand for a spectacle that incorporated Ethiopian and Egyptian scenes relating to the underworld. Turcan says: 'there were other indications that he celebrated the Isiac ceremonies that were officially attested later, and inscribed in the Roman calendar from 28 October to 3 November' (1996: 89). He also adds that the famous statue of Isis of the Capitol probably dates from this period. Her hairstyle shows the fashion adopted by Agrippina the Younger, the sister of Caligula, last wife of the Emperor Claudius and mother of Nero. Claridge (1998: 232), however, dates the statue to the third century AD.

If Caligula wished to transform the principate into a monarchy and establish his 'divine' right to rule, one way he could achieve this was to follow in the footsteps of his illustrious ancestor, Augustus, and import an obelisk to Rome. The one he chose (**5**) had originally been erected in the Julian Forum in Alexandria on the orders of

Augustus, a feat carried out by Cornelius Gallus, the first imperial prefect of Egypt after the Roman occupation. The obelisk was set up in Rome for Caligula by the Prefect Rubrius Barbarus and the architect Pontius.

While the obelisk was in Alexandria, an inscription had been fixed to its base. This has been reconstructed by Professor Magi, using the visible traces of the holes made for the insertion of the small metal tongues by which the individual letters were attached. According to Magi, the inscription reads as follows:

IVSSV IMP[eratoris] CAESARIS DIVI F[ilii] C[aius]
CORNELIVS CN F** GALLVS PRAEF[ectus] FABR[um]
CAESARIS DIVI F[ilii] FORVM IVLIVM FECIT

On the order of the Imperator Caesar, son of the god, C. Cornelius Gallus son of Gnaeus, the prefect of Caesar son of the god, made the Julian Forum.

It would appear that this inscription was removed after the condemnation and suicide of Gallus in 26 BC. In his inscription, Gallus merely mentions that Augustus was the man who had ordered the laying out of the square, otherwise dedicating it in his own name; this may well have been one of the acts of insubordination that led to his downfall.

In AD 37 Caligula ordered the forum demolished and the obelisk transferred to Rome. Once again the ship that transported it was preserved for many years, and was regarded as the most wonderful craft that had ever sailed. Later, the ship was towed to Ostia, on the command of Caligula's successor and uncle, the future emperor Claudius, where it was scuttled to form the foundation of part of the port that he was building.

The obelisk was the largest uninscribed obelisk ever to leave Egypt. Made of red granite, it stands 25.5 metres (83ft) high and weighs approximately 326 tonnes. In height this is second only to the obelisk of Hatshepsut at Karnak (**25**). Pliny refers to it as 'the third obelisk' and says it was erected 'in the garden of one Vaticanus

in the Circus of Gaius [Caligula]', which came to be later known as the Circus of Nero because of the slaughter of Christians that took place there on his orders. Pliny also says it was an imitation made by Nuncoreus(?), the son of Sesotris (*Natural History* 36: 11). The obelisk was certainly quarried in Egypt, but it is uncertain which king ordered it; nevertheless, the intention was that it should be set up at Heliopolis.

It is accepted by most scholars that Caligula dedicated the monument to his predecessors, the emperors Augustus and Tiberius, as the inscriptions on the front and back of the pedestal show:

DIVO CAESARI DIVI IVLII F AVGVSTO
TI CAESARI DIVI AVGVSTI F AVGVSTO
SACRVM.

Dedicated to the memory of the Divine Caesar Augustus and the divine Caesar Tiberius.

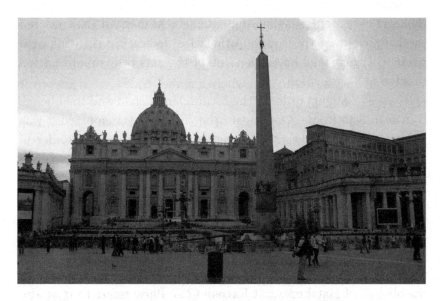

*6 Caligula's obelisk in St Peter's Square (**5**)*

There are some doubts surrounding this hypothesis. It seems odd that Pliny says nothing about an inscription on this obelisk, which he surely would have mentioned, had there been one. What seems even more strange is that the obelisk was originally set up by Caligula in the gardens he had inherited from his mother, Agrippina the Elder, who had been banished and eventually murdered by Tiberius. The obelisk was brought here not long after Caligula brought back his mother's and brother's (another victim of the Emperor Tiberius) ashes to Rome, where Caligula gave them an official burial in the Mausoleum of Augustus. It seems unlikely that he would at the same time have dedicated an obelisk to Tiberius, and placed the obelisk in his mother's gardens. The second objection is that the inscription is unique in that it is dedicated to a deified and an undeified emperor at the same time.

Because of its solid pedestal, the obelisk remained in situ for almost 1,500 years. Popular legend held that it stayed upright while others had fallen because it had witnessed the martyrdom of St Peter, who had been crucified on the site. From the mid-fifteenth century, a variety of popes had considered moving it to St Peter's Square, but financial and logistical complications had prevented them. Finally, under the direction of Pope Sixtus V (1585–86), it was removed and re-erected on the chosen site, where it stands today and is known as the Vatican obelisk.

The metal globe on the top of the shaft was said to contain the remains of Julius Caesar. When the globe was removed in the sixteenth century it was found to contain nothing but dust and was thrown away by the disappointed investigators. It was recovered and now the globe and its contents reside in the Museo dei Conservatori.

The re-siting of the obelisk in St Peter's Square was not straightforward. As previously mentioned, Pope Sixtus V was responsible for instigating the renaissance of the obelisks of Rome. He wanted to excavate and re-erect the obelisks known to be lying among the ruins in various parts of the city, for 'the honour of Christ

and His Cross'. Sixtus discussed the project with various dignitaries, and as no practical solution resulted from the meeting, he formed a committee to choose an architect who could be entrusted with the task of re-erecting the obelisk, the only one still standing on the Vatican site.

The Re-erection of the Obelisk

With the exception of the brief account supplied by the Roman historian Ammianus, there is no record of how obelisks were moved or erected in earlier times. The most detailed description that we have is in the 1590 work by Dominico Fontana (1543–1607), *Della Trasportazione dell' Obelisco Vaticano*. While it can only be a guide to how the ancient obelisks may have been erected, it nevertheless provides detailed information on the complexities involved, and helps put in perspective the achievements of ancient civilizations. The following extract of Fontana's work as given by Budge (1926: 42–7) is therefore of interest for understanding the enormity of the tasks faced by both Egyptian and Roman obelisk builders, as well as their sixteenth-century descendants.

The committee failed to appoint an architect for the project, and a prize was offered for the best plan to carry out the removal and re-siting of the obelisk. Budge gives the following account of the meeting, where a large number of engineers put forward a variety of proposals, which included:

> to remove it, with its pedestal, in an upright position; to take it down and re-erect it by means of a huge wheel; to incline it in a cradle to an angle of 45 degrees and then move it; to take it down and move it by means of a huge lever;) to lower and raise by means of endless screws worked vertically and horizontally. (Budge 1926: 42)

The plans of the various machines that would carry out the task were then submitted to the pope. Some of the drawings submitted by Fontana can be seen on one of the plates in his work, mentioned

above. Dominico Fontana's plan to lower the obelisk by laying it down and pulling it on rollers to the new site, where it would be raised by ropes worked by capstans, was the most acceptable to Sixtus, and he ignored all the other proposals and entrusted the entire scheme to Fontana.

Fontana set to work straight away and began clearing operations around the obelisk and at the same time prepared the square to re-house it. When he examined the monument he found it was leaning towards the Basilica of St Peter, and its *pyramidion* was 43 centimetres (17in) from the perpendicular. Work began on the trench at the new site in September 1585. The pope had given instructions for all buildings that might hinder the work to be removed, and also gave Fontana the authority to take anything he required to carry out the task from the papal stores.

> Wood was collected, ropes were made, capstans were built on a special plan, and every care was taken in choosing the right materials to be used for lowering and re-erecting the obelisk, estimated to weigh 325 tons. Forty capstans, each with four bars and the necessary sets of tackle were made, and these were worked by 800 men and 75 horses, and 5 great levers worked by 106 men. A huge scaffolding, 90 feet [27 metres] high, and of immense strength, was built to provide fixed points for the pulleys. . . . Each upright, made of oak and walnut, was four beams thick, and these were kept in position by key-bolts, iron bands and ropes, fixed at regular intervals. The uprights and their struts were secured by tie-beams and iron bands, etc., and the former were connected by trusses, to which tackle blocks were attached. The whole scaffolding was built on a heavy timber platform, and was referred to as 'Fontana's Castle'. . . .
>
> The obelisk was then covered on all sides with a layer of matting and planks of wood, which were kept in position by thick iron bars; these in turn were secured with iron bands, which served as points for the attachment of the lower blocks of the tackle. The obelisk was to be raised 2 feet [0.5 metres] above its pedestal on four bronze blocks, and so the iron

bars could be passed under the base of the obelisk without injuring the pedestal. The casing of rope, wood, and iron was estimated to weigh about 23 tonnes. (Budge 1926: 43–4)

Any buildings that stood in the way were demolished. When the pit had been dug, two stone boxes containing several medals and other items bearing the effigy of Sixtus were placed in it. Huge crowds arrived to witness the removal of the obelisk from its old site.

'At a blast of a trumpet the capstans began to turn, wedges were driven under the obelisk, and the tackles began to raise it to an upright position; a few hours later the obelisk had been raised 2 feet [0.5 metre] above the pedestal and all the machinery had withstood the strain' (Budge 1926: 45). On 28 April 1586, the date agreed for placing the obelisk on a cradle to take it to its new site, Fontana attended Mass at 2 a.m., accompanied by his workmen, and later offered up public prayers on the site to ensure the success of the project. The operation proved difficult. The obelisk had originally rested on four bronze crabs, two were loose, but the others were fixed firmly to the obelisk and the pedestal by dovetails. Therefore the crabs, each one weighing approximately 600 kilograms (1,320lb), had to be separated from the pedestal by chipping away the stone around them. Fontana decided to reuse the bronze crabs and the old pedestal to support the obelisk. Four double-bodied lions were set at the corners of the obelisk to hide the original crabs.

The next stage was to roll the obelisk, on its cradle, to its new home, about 300 metres away. 'As that was on a lower level, an embankment of earth had to be made, the sides of it were supported by strutted wood revetments with transverse and diagonal braces' (Budge 1926: 45). The height of this artificial 'roadway' went up from zero at the old site to 8 metres (27ft) at the new. At its base it was 22 metres (73ft) wide and at the top 11.5 metres (36½ft) The crowd were so enthusiastic and excited that, when the task was successfully completed, they carried Fontana home to a musical accompaniment of drums and trumpets.

The whole operation had taken six months to complete, but now the obelisk was ready to be re-erected. On 13 June the obelisk was dragged into St Peter's Square and on 30 August the square was closed to the public for work on the re-erection to begin. At dawn on 10 September, the men began raising the obelisk, which took them thirteen hours, with only one short refreshment stop. The obelisk was now standing in a vertical position above the pedestal, but separated from it by the cradle. The cradle was removed the following day, when the obelisk was lifted again and brought to rest on the wedges. A week later, the bronze crabs that were under the obelisk when it stood on its old site were replaced, and the obelisk came to rest firmly on its new site, where it has remained to this day.

A stone railing was erected to enclose the obelisk. To reward his success, Fontana was presented with the Golden Spur and a golden portrait medallion with a heavy chain. He also received a large pension and other privileges, as well as all the materials used in the transport of the obelisk.

There are several short Latin inscriptions on the pedestal. The north side records the dedication of the obelisk to the 'Invincible Cross' by Sixtus V. On the south side it records how Sixtus V removed the obelisk, which had been 'dedicated to the wicked cult of heathen gods, with great toil and labour into the precincts of the Apostles'. The east side calls upon those 'who are hostile to the Cross to flee, for the Lion of the tribe of Judah conquers'. Finally, on the west side, Christ's conquest and rule are proclaimed, and he is asked to protect his people from all evil. All the inscription texts were written by Cardinal Silvio, the inscriptions on the east and west sides are exorcist formulas.

The dedication ceremonies took place on 26 September 1586. A Mass was held in a neighbouring church, attended by a large number of people, including the Papal Court. Then all who had attended the Mass went in solemn procession to the obelisk, where more prayers were offered up. The obelisk was purified and surmounted by a bronze cross 2 metres (7ft 4in) high set into the *pyramidion*. This act

was commemorated by a Latin inscription on top of the obelisk that was added to the original dedication inscription supposedly made by Caligula to Augustus and Tiberius.

SIXTO V. PONT.MAX.OPT.PRINC.
FELICI PERETTO DE MONTE ALTO PA.
PA.OB PVRGATAM PRAEDONIB.ITA-
LIAM RESTITVTAM INSTAVRATAMQ.
VRB OBELISCVM CAES.E.CIRCO NERON.
IN MEDIAM D. PETRI AREAM INCREDIB.
SVMPTV TRALAT. ET VERAE RELIGIONI
DEDICATVM S.P.Q.R. AD REI MEMOR.
OBELISC.HVNC P.

When the best of princes Felice Peretti di Montalto was Pope Sixtus V, because Italy had been purged of bandits and restored, and the city renewed, the Senate and People of Rome placed this imperial obelisk of Caesar from Nero's Circus in the middle of St Peter's Square, after bringing it at incredible expense and dedicating it to the true religion, to commemorate the event.

In 1740 the cross was removed and a cavity was cut into it to hold certain relics of Christ—what the relics are remains a mystery.

The whole operation of removing and re-siting the obelisk cost 20,000 scudi, an enormous sum of money at the time. Today the obelisk makes an impressive sight; the whole monument, including the pedestal and cross, stands 40 metres (132ft) high, surrounded by the colonnades of the Basilica of St Peter. Due to its location it must be the most visited and photographed obelisk in the world.

CHAPTER 9

CLAUDIUS AND NERO
THE LAST OF AUGUSTUS' DYNASTY

C aligula's uncle Claudius (emperor AD 41–54) was a most unlikely candidate for emperor. He had been kept away from public office all his life because of his physical disabilities. He certainly did not fit into the image of the perfect Roman family that Augustus wanted to promote and was something of an embarrassment to the imperial family.

Caligula was assassinated in AD 41 by a group led by the commander of the Praetorian Guard, Cassius Charaea. The guards then went on a killing spree dispatching any member of the imperial household they could find; they discovered Claudius hiding behind a curtain in the imperial palace. Thinking it would be a great joke, they hoisted him aloft and declared him emperor: ironically the first 'true' emperor (elected by the people, rather than the Senate).

As emperor, Claudius had an even more pressing need to secure and justify his position than had Augustus. Apart from building the harbour at Ostia, which won him great acclaim, he also embarked on the invasion of Britain, a task that had been pending since Julius Caesar took the initial steps towards its conquest in 44 BC. Like his predecessors, Claudius was not immune to Egyptian influences, and may well have been involved in the revival of the worship of Isis. He may also have brought obelisks to Rome to adorn the Iseum or other places. The famous Mensa Isiaca, a bronze tablet inlaid in silver with divine figures and pseudo-hieroglyphs, was presumably made for a Roman sanctuary and is

dated to Claudius' reign; his name was added in hieroglyphs in a
cartouche.

Florence and Rome

Two obelisks that Claudius perhaps brought to Rome are the ones
now standing in the Boboli Gardens in Florence (**6**) and in the
Viale delle Terme di Diocleziano in Rome (**7**). The early twentieth-
century Egyptologist, E.A. Wallis Budge, says the obelisk that now
stands in the Boboli Gardens was removed from Egypt by Claudius
and originally set up in the 'Circus of Flora'(?) in Rome (Budge
1926: 213). He may be referring to the Flaminian Circus, which at
one time or another housed no fewer than eleven victory temples.
The obelisk was removed to the Medici Villa in Florence in the
seventeenth century. The granite shaft of this obelisk is nearly 5
metres (16ft) high and weighs about 4.5 tonnes. The cartouches of
Ramses II are cut on the *pyramidion*, and one column of hieroglyphs
occupies the centre of each face of the shaft. This obelisk has the
same inscriptions and decoration as the obelisk that is now in the
Viale delle Terme in Rome (**7**).

The pair were originally made by Ramses II and stood at
Heliopolis. They were removed to Rome, possibly to stand at the
entrance to the Iseum. The Terme obelisk is 9.25 metres (30ft) high
and is made of red granite. On the *pyramidion* is a winged scarab
with a sun disc and the two cartouches of Ramses II; on each side
of the shaft is a column of inscriptions, listing the king's names and
epithets, styling him as beloved of one or other of the solar gods
and mentioning his offerings in Heliopolis.

By 1870 Rome had become the capital of a united Italy, and a
commission was formed to direct excavations in the city. Priority
was given to the area that had once housed the Iseum, and on 20
June 1883 the Terme obelisk once again saw the light of day.

In 1887 a detachment of 548 Italian soldiers were ambushed
and killed in Ethiopia during the war precipitated by the Italian

invasion of Ethiopia. To pacify the Italian public it was decided that the obelisk should be erected as a memorial to these fallen soldiers. It was raised in front of Rome's main railway station, Termini, on a marble base adorned with bronze lions' heads and bronze tablets bearing the names of the fallen soldiers. The dedication took place on 5 June 1887 in front of the king, queen and nobility. In 1924 the square in front of the railway station was remodelled and the obelisk was removed to a garden south of the Viale delle Terme, where it stands today.

A bronze representation of the lion of Judah—the emblem of the Ethiopian monarchy—dedicated to the Emperor Menelik II (1889–1915) was also taken by the Italians in the 1930s and placed at the foot of the Terme obelisk and unveiled in a public ceremony on 9 May 1937. However, during the days that followed the liberation of Italy by the Allied troops in the Second World War, the bronze lion of Judah mysteriously disappeared, never to be seen again.

Claudius' successor, his stepson Nero, did not transport any further obelisks from Egypt, possibly because he was too preoccupied in rebuilding Rome after the great fire in AD 66. However, the imperial household welcomed Egyptian influences. Nero had as a tutor the Stoic, Chaeremon, who was captivated by Osirian theology, and his astrologer Balbinus took an active part in the Isis cult. Augustus' dynasty ended with the suicide of Nero in AD 68 and heralded a return to civil war in Italy.

CHAPTER 10

THE FLAVIAN EMPERORS AND THE OBELISKS OF DOMITIAN

The turbulent year of AD 69 saw no less than four contenders vying for the principate and was thus known as the 'year of the four emperors'. Galba lasted barely a month, having offended the aristocracy and the soldiers. The other commanders, Otho and Vitellius, had more success: they were able to win over much of the aristocracy, but they failed to establish their legitimacy in the eyes of their social peers as well as with the soldiers.

By July of that year Vespasian, the general serving in Judaea, was declared emperor in Egypt, followed by Syria and the rest of the east, receiving divine recognition of his right to rule from the god Serapis. There were many auspices in his favour: the Nile flooded on the day he entered Alexandria, he allegedly restored a blind man's sight and healed a cripple. When he was left alone in the Temple of Serapis he was said to have experienced both an oracle and a miracle.

The struggle for power between Vitellius and Vespasian was finally brought onto the streets of Rome, and by December Vespasian had emerged as the victor. In AD 70, on his return to Rome accompanied by his son Titus, he spent the night in the Temple of Isis on the Campus Martius before celebrating his triumph over Judaea. He needed to build powerful political alliances in order to secure his regime, and it is notable that Vespasian tended to concentrate political authority within his family circle to an even greater extent than had been the practice of the Julio-Claudians.

The new dynasty, the Flavian, lasted from AD 69 to AD 98. Its founder, Vespasian, began a long series of building projects in Rome: repairing buildings such as the Temple of Capitoline Jupiter, which had been damaged during the civil wars, and inaugurating new ones. The most famous of all the new projects was the Colosseum, which was completed during the reign of his son and successor, Titus. Like Augustus before them, the Flavians needed to legitimize their right to rule; massive expenditure on building works was one way of securing public support. Titus, however, did not reign long, dying of a fever at the age of forty in AD 81. His brother, Domitian, then became emperor purely through his family connection. In order to win over the populace, Domitian also embarked on a huge building programme that far outdid anything his father and brother had undertaken.

During the civil strife of AD 69 Domitian had fled the Capitol disguised as an Isiac devotee, which saved his life. Perhaps in recognition of this, Domitian completely rebuilt the Iseum Campense after the fire of AD 80. The new Iseum was the centre of worship of Egyptian gods in Rome, and was, according to Josephus, a magnificent structure (*Jewish Antiquities* 18: 4). It would therefore seem natural that Domitian should wish to grace the entrance to his newly rebuilt temple with a pair of obelisks. He also rebuilt the Iseum at Beneventum, where he was portrayed as a pharaoh. Domitian removed obelisks from Egypt as well as re-siting some of the ones brought to Rome earlier by Augustus.

The ideology of divine right to rule that had been so successfully employed by Augustus had set a precedent, albeit occasionally abused by some his successors. To the deep consternation of the Senate, Domitian designated himself as 'lord and god' in official documents. It therefore comes as no surprise to find one of the obelisks he set up in the Iseum should proclaim his divine right of kingship and is the only obelisk to depict the emperor as pharaoh (**10**).

In the Domus Flavia (Flavian Palace) on the Palatine Hill, fragments of sculptures retrieved may suggest that there had been

a chapel of Egyptian cults serving the imperial family. Domitian chiefly honoured Minerva—one of triad in the Capitoline Temple in Rome—but she was associated with the Greek goddess Athene, and there was also a close connection between that goddess and Isis-Neith of Saïs, who was an armed goddess likened to Athene.

The Rotonda Obelisk (8) and the Villa Mattei Obelisk (9)

The first of the two obelisks that Domitian imported to grace his newly completed Iseum in AD 80 is known as the Rotonda obelisk, from the site of its present location. The Italian archaeologist Antonio Nibby (1792–1839) believed that it was a replica made during the Roman period, but it has been shown by later experts to be an original Egyptian monument. It had stood before one of the pylons of the House of Rā at Heliopolis.

On the *pyramidion* are engraved 'the prenomen and nomen of Ramses II, and on each of the faces of the shaft is one column of hieroglyphs giving the titles of this king . . . Ramses styles himself "the reverer of those who gave birth to him, multiplier of their days"' (Budge 1926: 209). It stands 6 metres high (20ft) and was one of a pair that Domitian set up at the entrances to the Iseum, between the Saepta Julia (the permanent voting enclosure in the form of two monumental porticos, begun by Julius Caesar and completed by Agrippa in 26 BC) and the Temple of Minerva.

The obelisk was found in 1374 during the reconstruction of the Church of St Maria Sopra Minerva, which was built over the ruins of the Iseum. It is said to have been re-sited sometime later near the small Church of San Mauto, on the Via del Seminario, where it stood on its pedestal. There were also some fragments—possibly from the shaft—lying beside it. Why or how it was moved there is not known.

Pope Clement XI (1700–21) decided to re-erect it in the Piazza della Rotonda in front of the Pantheon. A fountain with water-spouting dolphins was made to replace an earlier one and to

serve as a base for the obelisk. The top is decorated with a cross surmounting a star, and dedicatory inscriptions and the papal coat of arms embellish the base.

The surviving partner obelisk now stands within the walls of a palace, the Villa Mattei (**9**), in Rome. Only the upper part remains standing, approximately 2.75 metres high (8ft) and bearing the names of Ramses II. A fragment of the lower part has been lost. A copy of the inscriptions remains, thanks to the efforts of the epigrapher Marucchi (1898), showing that the inscriptions on the two sides of this obelisk parallel those on the Rotonda obelisk.

According to references in contemporary documents, the obelisk was re-erected in the fourteenth century on the Capitoline Hill, to the east of the steps leading to Santa Maria in Aracoeli. It remained there for a century before it fell down. On 11 September 1582, the obelisk was presented to Ciriaco Mattei, a nobleman and collector of antiquities, by the City of Rome. It was placed in the grounds of his villa, the Villa Celimontana, in a hippodrome he had planned. Inscriptions on the base record the story of its donation.

Over time, due to lack of interest by the heirs of Mattei, the obelisk deteriorated and was about to fall when a chance event rescued it. During the Napoleonic wars, Charles IV of Spain and his queen abdicated and took refuge in Rome. Prince Manuel de Godoy, a former prime minister of Spain, accompanied them and took up residence at the villa. Godoy was a keen gardener and also something of an amateur archaeologist, and he decided to restore the villa and its grounds. He removed the obelisk to its current position in the villa's garden—the Grove of Muses—where it can be viewed today in a tranquil, traffic-free environment.

There is a rather gruesome story relating to the obelisk's siting. While it was being placed upon its pedestal, the architect—being overly anxious—tried to steady the monument by placing his hand upon the pedestal just as the cords were relaxed. The monument abruptly descended upon the pedestal and crushed his fingers. It was then impossible to raise the obelisk, so the architect's hand had

to be amputated, leaving his fingers under it—they are said to be there to this day.

Domitian's Divine Right to Rule? The Navona Obelisk (10)

One obelisk that Domitian brought from Egypt clearly displays the ideology of divine right to rule that was employed by Domitian. The obelisk was quarried at Syene, in Aswan, on his orders. Though there is no proof to substantiate the claim, some believe he originally erected it in one of the great temples in Egypt. It is made of granite and stands 16.5 metres high (54ft) and weighs about 93 tonnes.

The only genuinely Egyptian feature about this obelisk is the material from which it is made. It is unique as it is the only obelisk standing in Rome (or elsewhere, for that matter) to portray the emperor as pharaoh. In the vignettes on the *pyramidion* Domitian is seen worshipping the gods, and—like a pharaoh of ancient Egypt—he styles himself as the beloved of Rā-Her-aakhuti and the Golden Horus. He calls Rā-Her-aakhuti his father and says, 'He set up the great obelisk to him.' Domitian's Roman names and titles are given in two cartouches that read: Autocrator [Imperator]. Caesar Domitianus Sebastus [Augustus].

A single column of poorly cut hieroglyphs occupies the centre of each face of the shaft, copied from the obelisks of Tuthmosis III and Ramses II. The name of Domitian's brother and father are mentioned on the eastern shaft: 'He has received the kingdom of his father, Vespasian, in the place of his brother, Titus the Great, after his soul flew up into heaven.'

Domitian did not follow the traditional pattern used in decorating the *pyramidion*. Ancient pharaohs always depicted themselves making offerings to a single deity, or receiving the god's blessing; Domitian, however, depicted himself between two gods, who are giving him *their* blessings or presenting *him* with divine symbols. The scene that depicts the goddess Hathor or Isis has her presenting Domitian with a double crown, suggesting that this obelisk was intended to celebrate the accession of Domitian in AD 81. This is

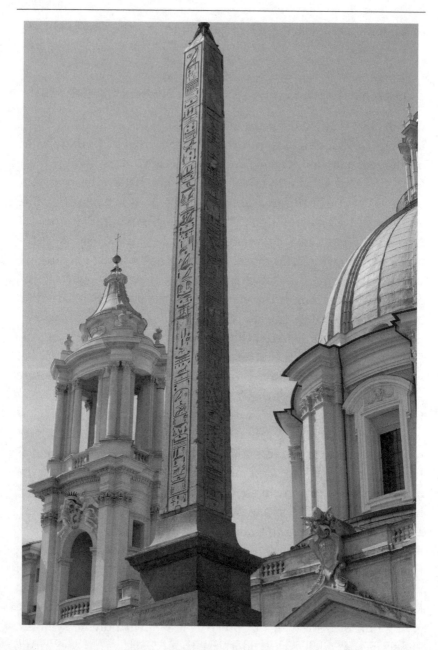

7 *Obelisk of Domitian in Piazza Navona, Rome (**10**)*

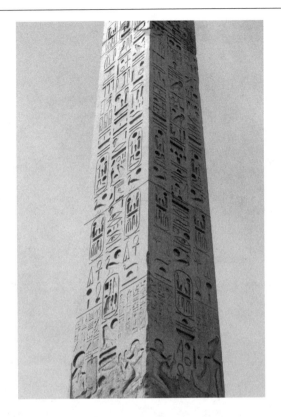

8 Inscriptions on the Navona obelisk, showing Domitian as pharoah

confirmed by the inscription on the shaft, which mentions the death of his brother Titus.

The obelisk stood near the Iseum for almost two centuries, until it was removed by the Emperor Maxentius (AD 306–312) to stand in the circus he erected in memory of his deified son Romulus, who died in AD 309. The remains of the circus are still visible today along the Appian Way.

At the beginning of the fifteenth century, the Florentine writer Poggio saw the obelisk among the ruins. We know from the journals of the sixteenth-century Monsignor Michele Mercati that he brought the fallen obelisk to the attention of Pope Sixtus V, and suggested

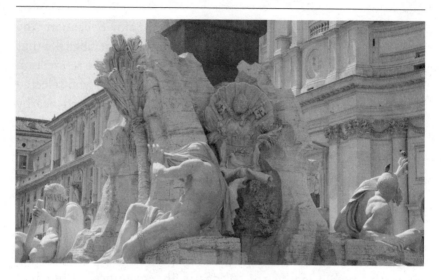

9 The statues at the base of the Navona obelisk

10 The Piazza Navona

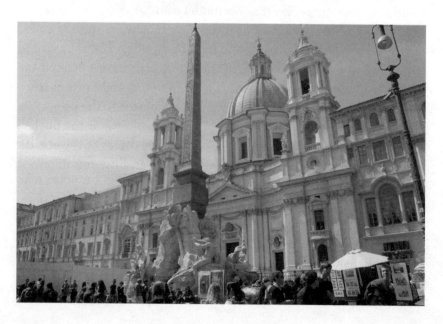

it could be re-erected before the Basilica of Saint Sebastian. The pope, though, felt there were other more important obelisks that warranted his attention, so he did nothing about it. The re-erection of this obelisk was left to Pope Innocent X (1644–55), who selected the Piazza Navona as the new site because he had lived nearby when he was a cardinal, and this was his way of leaving his mark for posterity. However, popular tradition says that the obelisk stands upon the spot in the Stadium of Domitian where the martyr St Agnes was burned to death during the persecution of the Christians under the Emperor Valerian in AD 258. Agnes was venerated as a virgin saint in Rome from the fourth century AD, and the earliest evidence for her cult dates to AD 354, but legends concerning her martyrdom vary considerably and nothing certain is actually known about the date or manner of her death. The magnificent Church of St Agnes built by Pope Innocent X stands opposite the obelisk.

Innocent appointed the architect Girolamo Rainaldi (1570–1655) to re-erect the obelisk, totally ignoring the more famous architect of the time, Giovanni Lorenzo Bernini (1598–1680). Nevertheless, Bernini had a plan for setting the obelisk above a fountain in the middle of the square. He made a model of his project, and a friend of his persuaded the widow of the pope's brother, a woman called Olympia Maidalchini, to place it in her house, where the pope visited from time to time. During one of these visits, Innocent noticed the model and was so impressed with it that he ordered Bernini to be sent to him immediately. So Bernini was appointed to the project on 11 April 1647 and in the summer of the following year the obelisk was transported to the Piazza Navona. The five pieces of the obelisk were not assembled until the following year, and the fountain not completed until the spring of 1651.

There was no cross placed on top of the obelisk; instead, there was the effigy of a dove, the heraldic symbol of the pope's family. The inscriptions on the pedestal give an account of the erection of the obelisk as well as an explanation of the meaning of the fountain below. Bernini made the fountain as an allegory of the four continents Asia, Africa, Europe and America, through a series

of caves that held symbols representing each continent. The river Ganges denotes Asia, and is shown by a reclining river god with an oar in his hand; Africa is represented by the Nile, shown as a god with a hidden face (perhaps denoting the mystery of the Nile's source); the mythical horse of the Danube represented Europe, while an American Indian, awestruck by the obelisk, represented America. There were other figures and animals interspersed on the fountain specific to each continent.

Far from being seen as a wonderful achievement, Bernini's work created huge consternation and a great deal of opposition. The re-erection of the obelisk had cost a large amount of money, and taxes had been raised to pay for it. This had caused loud protests to be directed at the pope and his family. Despite this, the people of Rome today, as well as its many visitors, view the obelisk and its fountain as a source of endless admiration.

Two Further Obelisks Attributable to Domitian (14, 15)

There are two further uninscribed obelisks—a pair made of Aswan red granite—that may not have been brought to Rome by Domitian, but were probably re-sited by him. The larger of the two (**14**) stands about 14.5 metres (48ft) high and weighs about 45 tonnes, while the other (**15**) is slightly smaller at 13 metres (45ft) high, weighing 43 tonnes; they appear to have been brought to Rome from Egypt as a pair. They were found at some time during the sixteenth century lying in the ruins of the Mausoleum of Augustus, but the writer Strabo (60 BC–AD 20), who described this building in the first century AD, makes no mention of them.

Many members of Augustus' family were buried in the Mausoleum, we know his nephew Marcellus (d. 23 BC) and his son-in-law Marcus Agrippa (d. 12 BC) were among them, as well as Augustus himself (d. AD 14). At that time two bronze plaques bearing the text of Augustus' own inscription, recording his achievements, were fixed at either side of the entrance. The last confirmed burial there was the Emperor Nerva in AD 96. The two

obelisks must have been erected at the mausoleum before it ceased to be an imperial burial place: therefore they must have been placed there not later than the second half of the first century AD. According to Ammianus, they were still standing there in the fourth century AD, although by that time their *pyramidia* had been removed. It seems highly probable that they were erected in front of the Mausoleum by the Emperor Domitian (AD 81–96); their bases have still to be located.

These two obelisks (**14**, **15**) both broke into three fragments at some point in time. They lay in the ruins of the Mausoleum of Augustus behind the sixteenth-century Church of St Rocco. In 1519 the fragments of one (**15**) were excavated and removed to a neighbouring street.

Pope Sixtus V was yet again responsible for the re-erection of this obelisk and wanted Fontana to supervise the work, but Fontana was busy at the time on the Vatican obelisk (**5**). So the pope ordered Bandino de Stabia to transfer the three fragments to the square behind the Basilica of Santa Maria Maggiore, in front of the gate leading to the pope's summer residence on the Esquiline Hill.

When Fontana had finished the work on the Vatican obelisk, he turned his attention to this obelisk (**15**) and was able to raise it in a short space of time. On 11 March 1587 excavations began on the place where the obelisk was to be put and by the following August it was set up. On 11 August the cross was fixed to the top and two days later it was dedicated. Once again the pedestal of the obelisk was adorned with inscriptions telling the story of the obelisk and who was responsible for its re-siting. One inscription in particular is intriguing, for it states that the Emperor Augustus 'so adored Jesus Christ as being born of the virgin and the reason that he [Augustus] refused to let himself be called Lord out of respect for the Lord Jesus'. This suggests that the discoverers of the obelisk must have thought that it had been brought to Rome by Constantine, as this statement could certainly not have been applied to the emperors of the first century AD.

Sixtus' plans extended to the Piazza del Quirinale. He had this square redesigned to facilitate access to the Quirinale Palace, which was also used as a summer residence for the popes. Fontana was involved again, and on this occasion he transferred a pair of statues known as the 'horse tamers' to the piazza, having first repaired those parts of the statues that had become damaged.

It would be almost two centuries later, in 1781, before the second obelisk of the pair (**14**) would be re-erected. Like its companion, it was found in three pieces and removed to a neighbouring street for storage. A little while later Pope Pius VI (1772–99) decided to have it erected in the Piazza del Quirinale, between the statues of the horse tamers, but it was a project that took five years to complete.

On 14 January 1782 a contract was given to the architect Antinori—who had re-erected the Montecitorio obelisk—to repair this obelisk, convey it to its new site and re-erect it. After many delays, the fragments were finally placed upon their pedestal on 3 October 1786. The dedicatory inscription was made and the obelisk was consecrated on 21 October. There was a great deal of criticism concerning the location of this monument, but it soon came to be much admired. Thirty-two years later, a large basin was placed below the obelisk and the horse tamers, placing the obelisk in a unique setting.

A further obelisk set up by Domitian, now outside Rome, also deserves mention. It is described by Budge:

> There stands in the square of the Cathedral at Benevento a part of the shaft of a small broken red granite obelisk which is about 9 feet [3 metres] high and weighs about 2½ tonnes; the pyramidion and part of the base are wanting. On each face of the shaft is a column of hieroglyphs containing the cartouche of Domitian. A portion of a similar obelisk is built into the wall of the bishop's palace [at Benevento]. (Budge 1929: 249)

Budge, among others, thought that this pair of obelisks had originally been set up by Domitian in front of the Temple of Isis in Beneventum. The founder of the temple was one Lucilius Lupus, and his name appears on the first of these two fragmentary shafts (Budge 1929: 249).

The fascination with Egypt continued into the second century, when the Emperor Hadrian fell under the spell of Egypt. By now the empire had expanded to its furthermost limits. For the emperor it was no longer a time of conquest but of consolidation.

CHAPTER 11

THE EMPEROR HADRIAN
A MEMORIAL TO GRIEF

A fter the death of his father, Hadrian had been placed under the guardianship of the man who later became the Emperor Trajan (AD 98–117). He embarked on a military career and married Trajan's grand-niece Sabina. Later, he was adopted by Trajan, and, shortly before Trajan's death, Hadrian was made his successor.

Hadrian (AD 117–138) was one of the most capable emperors. His rule was strong but not, by Roman standards, as oppressive as some earlier rulers. He was also a great patron of the arts. Much of Hadrian's reign was spent visiting the provinces of the empire and improving the defences of the frontiers. He left Rome for his grand tour in AD 128 and, naturally, one of the places he visited was Egypt. According to the fourth-century writer Epiphanius, the whole journey to Egypt was undertaken for the sake of his health (*De Mensuribus et Ponderibus* 14).

There is also evidence for Hadrian's presence in Heliopolis. The priests at the Temple of Rā performed sacrifices and explained the sacred rites to foreigners. Hadrian, it seems, wished to learn something about this secret lore; there is a papyrus, known as the Magical Papyrus, now in the Louvre in Paris, which tells of a 'spell of attraction' for the belief. This spell 'attracts those who are uncontrollable . . . it afflicts sickness excellently and destroys powerfully, sends dreams beautifully and accomplishes marvellous dream revelations'. The text claims that Hadrian witnessed such a demonstration:

The prophet of Heliopolis, Pachrates, revealing the power of his own divine magic, demonstrated it to the emperor Hadrian; for he attracted within one hour, made someone sick within two hours, killed within seven hours, and sent the emperor himself dreams. Thus the prophet proved the complete truth of his magical powers. The emperor marvelled at the prophet and ordered that he should receive a double fee. (Papyri Graeci Magici IV, in Betz 1985: 82)

There may have been other reasons for Hadrian's visit to Heliopolis. As noted earlier, Heliopolis was traditionally the home of the phoenix, and this bird had allegedly been sighted at the time of Hadrian's accession. There are many theories about the lifespan of the bird, some put it at 1,460 years, the length of the so-called 'Sothic cycle' (Sothis was the Egyptian name for Sirius, the dog star). The heliacal rising of Sirius was supposed to coincide with the Egyptian new year's day, 1 Thoth (29 August), but in reality did so every 1,460 years. According to Censorinus, a third-century writer, this coincidence occurred in the year AD 139. Hadrian must have been informed of the coming event and may have viewed it as a precursor to the coming nine hundredth anniversary of Rome's foundation.

There was to be a more sinister occurrence in Egypt. By the second half of October, Hadrian and his entourage reached Hermopolis, about 90 kilometres (60 miles) upstream from Oxyrhyncus. Hermopolis was the city of the god Thoth, the Egyptian version of the Greek Hermes, the. The festival of the Nile fell on the twenty-second day of the month, followed two days later by the commemoration of Osiris' drowning in the river. It may have been on this day that Hadrian's lover Antinous was drowned. The historian Cassius Dio supplies the fullest account of what happened.

Antinous was from Bithynium, a Bithynian city which we also call Claudiopolis, and he had become Hadrian's boy favourite [paidika]; and he died in Egypt either by falling into the Nile, as Hadrian writes, or, as the truth is, having

been offered in sacrifice. For Hadrian was, in any case, as
I have said, very keen on the curious arts, and made use
of divinations and incantations of all kinds. Thus Hadrian
honoured Antinous—either on account of his love for him,
or because he had gone to his death voluntarily, for there
was need for a life to be surrendered willingly, to achieve
what Hadrian intended—by founding a city on the spot
where he suffered this fate and naming it after him. (Dio
History 69: 11)

The account in the *Historia Augusta* is much briefer, so too is
Aurelius Victor's account, presumably derived from the same lost
biography of Hadrian by Marius Maximus on which the *Historia
Augusta* relied. It seems that the rumours concerning Antinous'
sacrifice may not have arisen if Hadrian had not shown Antinous
such honours after his death, or felt the need to insist in writing
that Antinous' death was accidental.

There is circumstantial evidence to suggest that what Dio says may
be true. The deified Antinous is identified or portrayed as various
Greek gods, especially Hermes, Dionysus and Pan, and was explicitly
merged with Osiris in the city named after him, Antinoopolis. The
fact that his death took place close to or even on the anniversary of
Osiris' death could well be more than coincidental. There was also an
ancient Egyptian practice that persons drowned in the Nile received
divine honours, something known by Herodotus and mentioned
again by Tertullian over 600 years later.

There may be another reason, postulated by the Hellenist scholar
Lambert (1984). He says that Antinous drowned himself, knowing
that Hadrian was concerned about his own health, and believing—
or having been told—that a sacrifice was needed. Aurelius Victor
accuses Hadrian of:

. . . debauching adult males and his burning passion for his
notorious attendant Antinous; and that it was for no other
reason that a city was founded named after Antinous, or that
Hadrian set up statues of the ephebe. Some indeed maintain

that this was done because of piety or religion; the reason being, they say, that Hadrian wanted to extend his own life span, and when the magicians demanded a volunteer to substitute for him everyone declined, but Antinous offered himself—hence the aforementioned honours done to him. We will leave the matter undecided although, in the case of an indulgent personality, we regard the association between persons of disparate age as suspicious. (Victor *Caeseres* 14: 5–7)

Therefore, Lambert implies, Antinous' position may have become untenable and so he sought a noble way out of the relationship.

On 30 October, Hadrian formally founded the city of Antinous (Antinoopolis) on the right bank of the Nile, opposite Hermopolis and close to the spot where Antinous had died. Presumably there had been some kind of funeral ceremony as well. An inscription from Heraclea Pontica on the Black Sea coast indicates the renaming before the end of the year AD 130 of the Association of Actors at Rome as the Sacred Hadrianic–Antinoan ... Synodos; the cult of Antinous was soon established.

The Monte Pincio Obelisk (11)

The merging of Antinous, Hadrian's lover, with Osiris can be seen in the surviving obelisk now in Monte Pincio, which may have been one of a pair he originally set up before the funerary temple built at Antinoopolis in AD 131 to commemorate the suicide of his lover.

It was quarried at Aswan on the orders of the emperor. It is 9.25 metres (30ft) high and weighs nearly 18 tonnes. The style of the inscriptions and the form of the hieroglyphs show that it was inscribed during the Roman period and indicate that the scribes who drafted the inscriptions possessed little knowledge of the Egyptian language, being unfamiliar with its syllabary and hieroglyphs.

The *pyramidion* is uninscribed and there are two columns of poorly shaped and badly cut hieroglyphs on each face of the shaft.

On the north side is the Emperor Hadrian offering a figure of the goddess Maāt, the god Her-aakhuti, and he is called 'Lord of Crowns, Hatrānes [Hadrianus] Krs [Caesar]'. The inscriptions on the south and east sides of the shaft make it clear that Hadrian gave orders that Antinous was to be worshipped as an Egyptian god, and we can be fairly certain that ancient Egyptian ceremonies were performed daily in the temple to ensure everlasting life for the emperor's lover.

On the east side there is a prayer addressed to Rā-Harachte, 'highest of the gods, who hears the cry of gods and men, of the enlightened ones and of the dead'. Osirantinous (Antinous) asks Rā to reward him (Hadrian), 'who has founded a rule of worship in the temples for all men . . . he that is beloved of Hapi and of all the gods, the lord of diadems—may he live safe and sound, may he live forever like Rā, in a fresh and rejuvenated old age'. Hadrian's wife Sabina is also included in the new god's prayer: 'the great royal lady beloved by him [Hadrian], Sābina, who lives, is safe and in health, the Augusta, who lives forever'.

The west side celebrates Antinous' deification:

> The god Osiris-Antinous, the justified, is become a youth with a perfect face . . . his heart rejoices after he has received a command of the gods at the time of his death. For him is repeated every ritual of the hours of Osiris together with each of his ceremonies as a Mystery . . . Lord of Thermopolis [Thoth], Lord of the word of god, rejuvenate his spirit!

On the north side, the city of Antinoopolis is referred to, with specific reference to the games to be held there:

> The competition place in his city in Egypt, named after him, for the strong [athletes] in this land, for the teams of rowers and the runners of the whole land and for all who belong to the place of holy writings where Thoth is present, and they receive prizes and crowns on their head...There are sacrifices every day on his altars.

The vignettes depict Antinous presenting vessels of wine and other offerings to Amun and to Thoth, who hold out to him an ankh, the symbol of life. Antinous is called Osiris and he is said to 'breathe the breath of life' and that 'his soul is like that of Rā'. He, like Osiris is called the 'truth speaker', indicating that his soul was believed to have been weighed in the great scales and 'found to be a speaker of the truth'. He follows Osiris wherever he goes in Ta-tcheser (the holy land of the dead), and the guardians of the portals of heaven throw wide open the gates for him to enter. Antinous is constantly identified with Osiris the truth speaker.

Although this obelisk (as well as the temple dedicated to Antinous) was originally in Egypt, the early Egyptologists Birch and Adolf Erman believed there must have been a tomb or at least a cenotaph of Antinous in Rome. The inscription on the southern side of the shaft recorded that the deceased Antinous rests in the sanctuary, which is within Sekhtiqet of the Lady of Thebes Harma (i.e. Rome). The inscription continues:

> He is known as a god in all the divine shrines of Kam (*i.e.* Egypt), a temple has been built for him and he is worshipped as a god by the priests and libationers in the South and the North. A city is named after him ... and the Atmiti soldiers of the Lords of the North (*i.e.* Greeks) come thither, camps are provided for them, and they make happy their life there. A temple of this god is there called by the name of Osiris Antinous; it is built of beautiful stone and has sphinxes and many statues similar to those which the Greeks make, all the goddesses give to him the breath of life, and he breathes the air which makes him young again. (Budge 1926: 252–3)

Birch suggested (1852–53: 9ff) that, as Antinous was worshipped as Osiris in his temple in Egypt, we have to assume that he had been mummified; otherwise the Egyptian funerary ceremonies performed for him would have been meaningless. He wrote that it is also clear that—as there was a tomb or cenotaph for him in Rome—Hadrian must have had his mummified body brought from

Egypt. Erman believed that: 'Sehti-qet, mentioned in the text, was a district close to Rome and that its situation was signposted by the obelisk, which was located outside the great gate of the vineyard of Saccoccia, which is called by some archaeologists the Circus Varianus; because the obelisk once stood in the Circus Varianus' (Budge 1926: 254). This is the place where Erman believed the tomb originally stood when the circus was built by the Emperor Elagabalus (AD 218–222). On the other hand, Birch believed that the obelisk was brought there from some other location, and Parker (1876, in Budge 1926: 254) thought that Elagabalus moved it here in AD 220 to decorate the *spina*. Iversen (1968), in a more recent assessment, believes that the tomb was annexed to the goddess Tyche-Roma, but its location has not yet been discovered.

The obelisk only makes sense, though, not as a kind of elaborate funerary monument, but as an integral part of the new cult of Osiris-Antinous in the new city of Antinoopolis—the only place where the god Antinous was worshipped in this form. It would therefore make sense for his body to buried here and not in Rome. In that case, the obelisk must have been taken to Rome by a later emperor, after the cult of Antinous had ended.

The obelisk suffered at the hands of the Goths in the fifth century AD and remained where it fell until the seventeenth century. During the pontificate of Urban VII (1623–44) it was found, broken into three pieces near the Church of Santa Croce in Gerusalemme, which had been built on the site of the Circus Varianus.

The obelisk came into the private possession of many different people and travelled to various locations. Pope Urban VII wished to set it up near the Barberini Palace, but nothing came of the plan. It remained buried in the ruins until Domina Cornelia Barberini, the last relative of Urban, gave it to Pope Clement XIV (1769–72). Clement had it transported to the garden of the Pigna in the Vatican, where it lay until 1822. Finally, in September 1822, the obelisk was repaired and removed on the orders of Pope Pius VII to the site where it stands today in Monte Pincio (Viale del Obelisco).

* * *

There is a possibility that the obelisk that now stands in front of the Church of the Trinitià del Monte (**12**) is a copy made in antiquity by an emperor with a strong interest in Egyptian history, notably Hadrian, and it might originally have adorned his palace at Tivoli. It is made of red granite, quarried at Aswan, and stands almost 14 metres (45ft) high and weighs about 40 tonnes. The *pyramidion* has no vignettes, but on each side of the shaft are three columns of hieroglyphs, with the central lines containing the cartouches of Seti I and the side lines the cartouches of Ramses II. It is also decorated with a copy of the inscriptions that appear on the Flaminian obelisk in the Piazza del Popolo.

Iversen wrote that:

> . . . judging from the poor workmanship of its hieroglyphic inscription, Zoëga [the early Egyptologist 1755–1809] assessed the time of its transportation to Rome during the period between the emperors Commodus (AD 192) and Gallienus (AD 268), a dating supported by its inscription, which is a late copy of the Augustan obelisk, now standing in the Piazza del Popolo, as well as by modern archaeological evidence. (Iversen 1968: 128)

He also pointed out that the foundations on which the obelisk was first erected were deeper than the surrounding buildings, which date from the fourth or fifth century AD, therefore placing the obelisk's erection to some time around the third century AD. Ammianus may be referring to this obelisk when he says, 'And subsequent generations have brought over other obelisks of which one was set up on the Vatican, one in the gardens of Sallust, and two at the mausoleum of Augustus (*History* 17: 4, 16).

The foundations of the gardens of Sallust where the obelisk was re-erected in antiquity can still be seen. When the Goths under Alaric sacked Rome in AD 410, they entered by the Salarian Gate and burned the house of Sallust; it was probably then that the obelisk was pulled down and damaged. It was originally going to be re-sited

by Sixtus V in front of the Church of Santa Maria degli Angeli, but the plan came to nothing. Athanasius Kircher pointed out a century later that the inscription on the obelisk was a copy of the one on the Augustan obelisk in Popolo, and suggested to the pope, Alexander VII (1655–67) that it could be re-erected, but to little avail.

During the pontificate of Clement XII (1730–40), the obelisk was finally transferred to the Piazza di San Giovanni, where it lay for forty-five years. Sometime during that period there were abortive negotiations to take it to Paris to stand in front of the Cathedral de Notre Dame. Finally, Pope Pius VI (1772–99), despite many protests, decided to have it set up on front of the church in Trinitià del Monte (**12**), where it stands today.

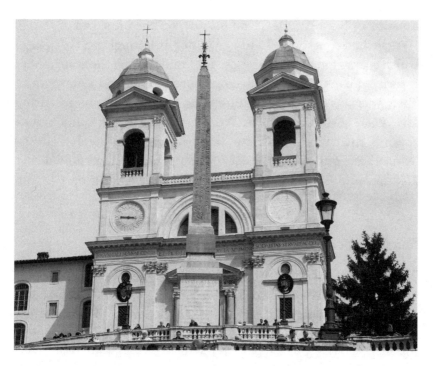

11 *Trinitià del Monte. One of the four obelisks (**12**) moved from the gardens of Sallust*

This was not the end of the obelisk's story: in 1843, when an attempt was made to plant a tree in the gardens where the obelisk had once stood, the base of the obelisk was unearthed. This was removed and placed in the Villa Ludovisis, almost opposite where it had been found. It remained there until 1926, when it was decided that it would be better employed as a memorial to the Fascist march on Rome of 22 October 1922. The base was appropriately decorated and, on 28 October 1926, it was dedicated at a new site on the Capitoline Hill.

It was said at the time that the foundations of the obelisk might endanger the church and the surrounding buildings, and that its erection above the Spanish Steps might ruin the view. Today this obelisk is one of the most visually striking of all the obelisks in Rome.

Hadrian's obsession with Egypt can also be glimpsed at the remains of his villa, the Tivoli (Tibur), on the outskirts of Rome. Here he had constructed a model Canopus leading to a Serapeum, which was a kind of cavern whose fountains cooled the atmosphere for sacred banquets, modelled on those celebrated in Alexandria. There was also a whole collection of Egyptian statues representing Isis, Osiris, Harpocrates and others. A series of coins struck towards the close of Hadrian's reign show Isis as the dog Sothis, as on the pediment to the Iseum Campense. Other coins depict Hadrian and Sabina being welcomed to Alexandria by Isis and Serapis.

The Obelisk at Caesarea, Israel (21)

There is one final obelisk that may be associated with the Emperor Hadrian that has come to light recently. It was rediscovered in the 1980s at Caesarea in Israel, broken into three pieces, and the authorities decided to reconstruct it. Caesarea is approximately 50 kilometres (80 miles) north of Tel Aviv. It was built by King Herod the Great (37–4 BC), the client king of Judaea, and named Caesarea in honour of his Roman patron, the Emperor Augustus.

The ruins of the ancient town lie close to the modern one and form part of the popular coastal resort. The town fell into decline during the Muslim conquest around AD 640 but was reinstated during the thirteenth century. All that remains today are the ruins, with only the Roman amphitheatre, aqueducts, hippodrome and Crusader fortress remaining.

The obelisk was discovered in the ruins of the hippodrome (where the games would have been held) and, according to the excavators, probably dates to the second century AD. It could well have been erected as a decorative centrepiece, mirroring those in the *spina* of the Circus Maximus in Rome. It is not known which emperor was responsible for its erection, although it could possibly have been Hadrian, in memory of his tour of the provinces. Caesarea was the residence of the procurator of Judaea, and for six years had housed the Roman *colonia*, so it is highly possible that Hadrian used this as his base for his tour of the province.

As there is no inscription on the obelisk there is nothing to connect it to any pharaoh—indeed it could possibly be a Roman copy. The obelisk is made of red granite and was originally 15 metres (49ft) high (only 12 metres (39ft) now remain), and weighs approximately 100 tonnes. The obelisk fell sometime between the seventh and thirteenth centuries AD. The Israel Antiquities Authority carried out the reconstruction project using concrete to replace the missing parts, holding it together with titanium pins and epoxy adhesives. It was officially re-erected on the site of its discovery on 18 June 2001.

Another intriguing find from Caesarea was a statue of the deified Antinous (Saignac 1904). It would appear from this that Hadrian was attempting to encourage the inhabitants of Caesarea to participate in the cult, so it is quite likely that he was responsible for the obelisk's erection as well.

Hadrian was not the last emperor to import obelisks from Egypt. Later emperors continued the affiliation with Egyptian cults: Septimius Severus (AD 193–211) conferred imperial favour upon

them; his son, Caracalla (AD 198–219), pledged a special cult to Serapis, building a gigantic temple to his god on the Quirinal. An inscription from Caracalla's baths proclaims: 'One and only is Zeus Sarapis Helios, invincible master of the world'.

The cult of Serapis continued through the centuries and enjoyed favour among the Roman people. Even the Emperor Diocletian (AD 285–305), a staunch advocate of traditional Roman religious values, had a new sanctuary of Isis and Serapis built in Rome. He perhaps also harboured some feelings of 'Egyptomania': in his palace at Spalato (Salonae) fragments were found of eight sphinxes and various other Egyptian-style monuments. In fact, one of the regions of Rome came to be known as Isis and Serapis.

With the rise of Christianity and the advent of the anti-pagan laws enforced by the Emperor Constantine I (AD 307–337) and his sons, the cult began to decline. However, during the reign of Constantius II (AD 337–361) a kind of amnesty was observed between the polytheistic Roman aristocracy and their Christian emperor. All this would be overturned with the succession of Julian the Apostate and a reversion, albeit temporary, to paganism.

CHAPTER 12

CONSTANTINE AND THE NEW ROME

The Obelisk in Piazza di San Giovanni in Laterano (13)

The obelisk that now stands in the Piazza di San Giovanni is the largest surviving obelisk in the world: it stands 32 metres (83ft) high and weighs 455 tonnes. It was made of red granite, possibly from the same quarry as the Vatican obelisk (**5**).

It was probably Min, the mayor of Thinis, overseer of the priests of Onuris, who supervised its original construction for the eighteenth-dynasty pharaoh Tuthmosis III (1479–1425 BC). It was originally intended to stand in one of the courts of the Temple of Amun-Rā at Karnak; it was brought from the quarry and deposited in the temple but the king died before it could be inscribed and set up. His son, Amenhotep II, who reigned for approximately twenty-five years, did nothing with it. Tuthmosis III's grandson, Tuthmosis IV (1419–1386)—jealous of his grandfather's achievements—had the obelisk inscribed with the usual dedication of Tuthmosis III and added his own inscription. Then he set it up in a place of his choosing near the great upper gate of Karnak, opposite Thebes. In his inscription he says that the obelisk had lain untouched for thirty-five years.

Its exact original siting in Egypt is uncertain. The French Egyptologist Lefebvre (1897–1957) considered various possibilities. Using the information in the inscription that the obelisk had been destined for the upper court or gateway of the temple, he deduced that it must have been placed to the east of the main temple. Another French Egyptologist, Paul Barguet, excavated to the east of

the festival hall of Tuthmosis III and unearthed four huge sandstone blocks, which had originally formed the base of an obelisk, but whether it was the base for this one is not clear.

The *pyramidion* and the upper part of the shaft were once plated in gold. On each face of the *pyramidion* the king is shown receiving the blessing of Amun-Rā or Amun-Aten. On the upper part of the shaft, in a rectangular frame, the king is once again shown making offerings to the gods. Below the inscriptions, scenes were added later by Ramses II, of which only those on the front face survive.

Constantius II (AD 337–361) was the second of the three sons of Constantine I 'the Great' (AD 307–337). When Constantine died in AD 337, Constantius II led the massacre of his relatives, leaving himself, his older brother Constantine II, his younger brother Constans and two cousins (Gallus and his half-brother Julian) as the only surviving males related to Constantine. The three brothers divided the Roman Empire among them, in accordance with their father's will. Constantine II received Britannia, Gaul and Hispania; Constans ruled Italia, Africa and Illyricum; and Constantius ruled the East.

Constantius took an active part in the affairs of the Christian Church, convening one council at Rimini and its twin at Seleuca, meeting in 359 and 360. Jones (1962) is of the opinion that the advice he took from his theologians was unsound, and eventually it was the malcontents that became victorious, thus tarnishing Constantine's memory. The great councils of 359–60 are therefore not reckoned ecumenical in the tradition of the Church, and Constantius II is not remembered as a restorer of unity, but as a heretic who arbitrarily imposed his will on the Church.

The Roman historian and soldier Ammianus Marcellinus says that Constantius was a conscientious emperor but a vain and stupid man, an easy prey for flatterers. He was timid and suspicious, and people could easily play on his fears for their own advantage. Ammianus also notes that Constantius II murdered many Roman aristocrats on the merest hint that they might be seeking the

empire for themselves; he killed one because he had a dream about him, and another because he had a purple tablecloth that might have been fashioned into the robe of an emperor.

Constantius II was the last Roman emperor to bring an obelisk to Rome, which he may well have done as an act of appeasement to the Church. The obelisk he imported was the obelisk that Constantine I had intended to erect in the capital of his new Rome, Constantinople. It is unclear why Constantine I wanted to remove the obelisk from Egypt, but perhaps he intended it as a symbolic gesture of the victory of Christ over the pagan. Nevertheless, one thing seems clear: like Augustus before him, he wished to use the obelisk as a political tool to reconcile East and West.

Ammianus Marcellinus wrote in the fourth century AD about the sites he visited in ancient Thebes. Ammianus had travelled widely throughout Egypt and was a great admirer of its monuments. He was present when the obelisk of Tuthmosis III at Karnak was transported from Egypt by the Emperor Constantine, and he is a valuable source for the details of its removal and the original intention that the obelisk would be taken to adorn Constantine's new capital of Constantinople. Ammianus gives us a detailed account of its re-erection in Rome. According to his account, the obelisk had been standing at Karnak when the Emperor Augustus first considered taking it to Rome. It appears that Augustus changed his mind, and Ammianus supplies us with a reason: 'He [Augustus] left it untouched because it was consecrated as a special gift to the sun god and because, being placed in the sacred part of his sumptuous temple, which might not be profaned, there it towered aloft like the peak of the world' (*History* 17: 6–10). Three centuries later, the Emperor Constantine I:

> Making little account of that [the reason why Augustus had not removed it], he tore the huge mass from its foundations; and since he rightly thought that he was committing no sacrilege if he took the marvel from one temple and consecrated it in new Rome, that is to say, in the temple

of the whole world [Constantinople], he let it lie for a long time, while the things necessary for its transfer were being provided. (Ammianus *History* 17: 4, 15–18)

This would imply that Constantine I was, like Augustus before him, in need of legitimization for his new reign from his new capital. The obelisk once again provided that visual symbol of authority sanctioned by divine right.

The obelisk was difficult to remove because of the other monuments standing around it, and unfortunately its pedestal and some of its foundations were destroyed in the process. Finally, it was conveyed down a channel of the Nile and reached the Egyptian port of Alexandria to await the building of a ship suitable to transport it. Constantine died in AD 337, before he could realize his ambition, and the obelisk spent the next twenty years waiting in Alexandria before making its journey instead to Rome on the orders of Constantine's successor, Constantius II. Ammianus says this was done because:

Sycophants [in Rome] after their fashion, kept puffing up Constantius and endlessly dinning it into his ears that, whereas Octavian [Augustus] had brought over two obelisks from the city of Heliopolis in Egypt, one of which was set up in the Circus Maximus, the other in the Campus Martius, as for this one recently brought in [to Alexandria] he neither ventured to meddle with it nor move it overawed by the difficulties of its size. (Ammianus *History* 17: 4, 12)

We have some interesting information from Ammianus concerning the obelisk's transportation: the ship originally constructed to take it to Constantinople but used to convey it to Rome instead, was a trireme of unknown dimensions manned by 300 oarsmen. It was taken up the channel of the Tiber to Alexandria, one of the regions of Rome, about three miles downstream from the capital. The obelisk, lying on a cradle with rollers, was transported through the Ostian Gate and the public fish market to the Circus Maximus,

where it was erected as a companion to the one already raised here by the Emperor Augustus.

Ammianus recounts how it was erected when it arrived at the Circus Maximus:

> After this there remained only the raising, which, it was thought, could be accomplished only with great difficulty, perhaps not at all. But it was done in the following manner: tall beams were brought and raised on end (so that it looked like a grove of machines), fastened with long and heavy ropes in the manner of a web of innumerable threads, hiding the sky with their density. To these was attached that veritable mountain [obelisk] engraved over with written characters, and it was gradually raised up on high through the empty air, and after being suspended for a long time, many thousands of men turned it around and around resembling a millstone until it was finally placed in the middle of the Circus and capped by a bronze globe gleaming with gold leaf; this was immediately struck by a bolt of divine fire [lightning] and therefore removed and replaced by a bronze figure of a torch, likewise overlaid with gold foil and glowing like a mass of flame. (Ammianus *History* 17: 6–10)

Constantius officially inaugurated the obelisk early in the year AD 357. It was the last great pagan monument to be brought to and erected in Rome, just prior to the establishment of Christianity as the official religion of the Roman Empire. So, for the Roman populace, it may have symbolized the victory of the new religion over paganism.

At some point the obelisk fell and broke into three pieces; it is unknown whether this happened during the sack of Rome by the Goths or later as a result of an earthquake.

This obelisk was another one that Fontana re-erected on the orders of Pope Sixtus V. There is a sixteenth-century account of the re-erection of Constantine's obelisk by Monsignor Michele Mercati (in his *Degli obelischi di Roma*, 1589), who was responsible for bringing

the obelisk to Sixtus V's attention, resulting in the pope giving the orders for a search to be carried out to locate it.

The likely site was probed and eventually, on 15 February 1587, the remains of the obelisk were located, roughly 7 metres (23ft) below the surface in the marshy remains of the Circus Maximus. The obelisk had been broken into three pieces and it was no easy task to drag them through the narrow streets to the site of its new location. The whole operation took a year to complete, but Fontana finally succeeded in re-erecting the obelisk in the Piazza di San Giovanni in Laterano. His method of raising the obelisk is described in his work *Della Trasportazione dell' Obelisco Vaticano* (1590); on 3 August 1588, the obelisk was finally placed in the piazza, resting on a new pedestal with four lions and scenes recounting its history. A cross was placed on the top. On 10 August the obelisk was consecrated.

The Obelisk at Arles (18)

Another obelisk was removed from Egypt by Constantine I and set up in Arles (France). Arles was a favourite city of Constantine; he built baths here as well as an amphitheatre, the impressive remains of which are still to be seen. Arles became a cultural and religious centre during the fourth century AD.

The obelisk is uninscribed and is made of red granite. It was originally erected in the *spina* of the circus in Arles (part of which is still visible near the archaeology museum). It fell down in late antiquity and broke into two parts, but was rediscovered in 1389. Later, Louis XIV had it re-erected in front of the town hall, in the centre of Place de la République.

CHAPTER 13

FROM ROME TO CONSTANTINOPLE

From AD 364 to 375, the Roman Empire was governed by two co-emperors, the brothers Valentinian I and Valens; when Valentinian died in AD 375, his sons Valentinian II and Gratian succeeded him as rulers of the Western Roman Empire. In 378, after Valens was killed in the Battle of Adrianople, Gratian appointed Theodosius to replace the fallen emperor as co-augustus for the East. Gratian was killed in a rebellion in 383, and Theodosius' elder son, Arcadius, was appointed co-ruler for the East. After the death in 392 of Valentinian II, whom Theodosius had supported against a variety of usurpations, Theodosius ruled as sole emperor, appointing his younger son, Honorius Augustus, as his co-ruler for the West. Theodosius defeated the usurper Eugenius on 6 September AD 394 at the Battle of the Frigidus and restored peace. The empire was united, once again under a sole emperor.

Theodosius promoted Christianity within the empire. On 27 February AD 380, he declared 'Catholic Christianity' to be the only legitimate imperial religion, ending state support for the traditional Roman religion. In the fourth century, the Christian Church was wracked with controversy over the divinity of Jesus, his relationship to God and the nature of the Trinity. In 325, Constantine I had convened the Council of Nicaea, which asserted that Jesus, the Son, was equal to the Father, one with the Father, and of the same substance (*homoousios* in Greek). The council condemned the teachings of the theologian Arius, who propounded the belief that the Son was a created being and inferior to God the Father, and that the Father and Son were not of a similar substance and not identical. Despite the council's ruling, controversy continued. By the time

of Theodosius' accession, there were still several different church factions that promoted alternative Christology, but Theodosius supported the conclusions of the Council of Nicaea—otherwise known as Nicaean Trinitarism.

Theodosius' Obelisk in Istanbul (16)

During his reign as emperor (AD 379–395), Theodosius ordered an obelisk to be removed from Egypt, destined for the new capital, Constantinople. This red granite monument now stands in the Atmeidan or Square of Horses in Istanbul, which was the site of the hippodrome of ancient Constantinople. The obelisk appears to have remained here ever since it was brought from Egypt.

The monument was originally set up in Egypt by Tuthmosis III (1479–1425 BC), possibly on the south side of the seventh pylon, on the transverse axis of the Temple of Amun at Karnak. It was erected in the thirty-third year of his reign to commemorate his conquests in western Asia and one of his most significant military victories, the successful crossing of the river Euphrates in Syria. When it was complete it was one of the largest obelisks ever made in Egypt, but it was broken, probably during its transportation to Constantinople, and now stands only 20 metres (66ft) high and weighs 800 tonnes; it was reported that the lower half of the obelisk also once stood in Constantinople.

In the late 1960s the Franco-Egyptian Centre in Karnak found the ramps that the Romans had used to lower this obelisk. The direction of the hieroglyphs on the shaft indicates that it stood on the west side of the temple doorway. The lower part of the shaft of its companion still stands at Karnak on a huge pedestal to the east of the doorway, amid numerous fragments scattered around. The inscriptions on the surviving fragments show that this obelisk matched the one now in Istanbul.

On each of the four faces of the *pyramidion* is cut a rectangular vignette in which the king is seen standing in front of Amun. Below each of these, cut on the side is a rectangular vignette in which

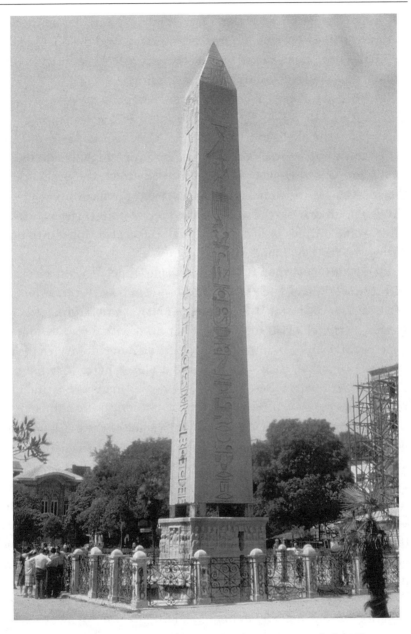

12 *Obelisk of Theodosius I/Tuthmosis III in Istanbul (**16**)*

the king is represented making offerings to Amun. An epithet of Tuthmosis III as 'Lord of Jubilees' is also given, and the obelisk may originally have been raised on celebration of such a festival. The lower parts of all the inscriptions are missing.

The obelisk was probably taken from Heliopolis to Alexandria by Constantine (AD 307–337), with the intention of transporting it (along with the obelisk in Piazza di San Giovanni in Laterano, **13**) to Constantinople to be erected there. The Emperor Julian (AD 361–363) wrote a letter asking the Alexandrians to send the obelisk to Constantinople and promised them a statue of himself in exchange. The Alexandrians agreed and built a special ship to transport it. After some initial problems, it finally reached Constantinople during the reign of Theodosius.

Theodosius' governor at Constantinople, Proclus, was entrusted with the work, and had the obelisk re-erected, as recorded on the pedestal. The pedestal is 3.5 metres (12ft) square and nearly 1.5 metres (5ft) high. Two steps were built on it with a total height of 1 metre (3ft). The corners of the pedestal were repaired with pieces of Theban marble, each 45 centimetres (18in) high. It is divided into two sections, the lower part preserves the inscriptions and two scenes showing the obelisk.

The bas-reliefs on the north and south sides of the pedestal were described by the travellers Jacob Spon and George Wheeler in their book *Voyage d'Italie, de Dalmatie, de Grece et du Levant, fait dès années 1675 & 1676*. The north side of the obelisk depicts its re-erection: in the top right-hand corner is a five-arched construction, which was believed to represent the barrier keeping the spectators away from the scene of the operation. In front is the obelisk lying on a sledge, one of whose large wheels is shown next to the shaft's square end. Ropes attached to four capstans are hauling the obelisk, each one worked by four men. A man with his right hand raised is giving directions and a man standing on the block appears to be watching the progress of the work. The actual setting up of the obelisk on its plinth is not shown, but in a second diagram we see it standing upright. On one side is a man carrying what appears to be a person

13 Drawing of some of the bas-reliefs on Theodosius' obelisk in Istanbul

who has been injured, on the other are three men: one cleaning the obelisk, one holding a hammer aloft in his left hand and a third who is most probably giving directions. The diagrams from the south side of the pedestal show two obelisks, a pillar, two mounted horsemen, two men apparently offering torches to sacred pillars and a victor in the games, who is about to be crowned. The upper part of the pedestal shows the emperor and his court, presumably as spectators of the chariot races in the circus around the obelisk.

The naturalism of traditional Roman art in such scenes gave way in these reliefs to conceptual art: the idea of order, decorum and respective ranking, expressed in serried ranks of faces. This is seen as evidence of formal themes beginning to oust the transitory details of mundane life celebrated in pagan portraiture, reflecting the adoption of Christianity as the new state religion. The Forum Tauri in Constantinople was renamed and redecorated as the Forum of Theodosius, including a column and a triumphal arch in his honour.

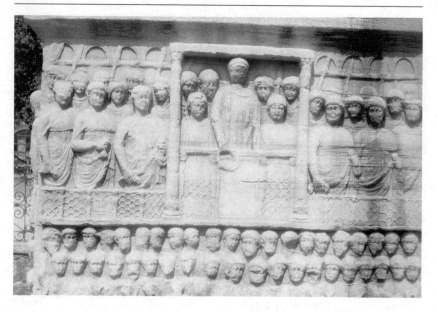

14 *Theodosius and his sons on the base of the obelisk*

There are two inscriptions: one in Greek and one in Latin. They are both now almost illegible, but they were copied and translated by the nineteenth-century traveller Hobhouse. The Latin text reads:

DIFFICILIS.
QVONDAM.DOMINIS.PARERE.SERENIS
IVSSVS.ET.EXTINCTIS.PALMEM.PORTARE.TYRANNIS
OMNIA.THEODOSIO.CEDVNT.SOBOLIQVE.PERENNI
TER.DENIS.SIC.VICTVS.EGO.DOMITVSQVE.DIEBVS
IVDICE.SVB.PROCLO.SVPERAS.ELATVS.AD.AVRAS

I was once unwilling to obey Imperial masters. But I was ordered to bear the palm [i.e. to celebrate the victory] after the destruction of tyrants. All things yield to Theodosius and his enduring offspring. Thus I was conquered and subdued in thirty days and elevated towards the sky in the Praetorship of Proclus (translation by Hobhouse, in Budge 1926: 164)

The same idea was repeated in Byzantine Greek on the west face:

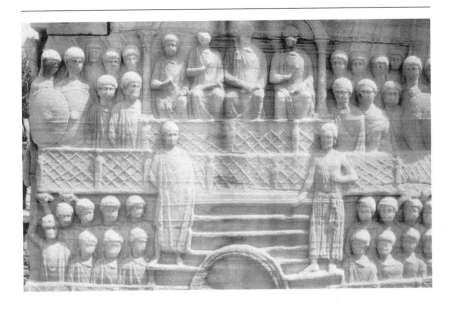

15 *Theodosius receiving honours on the base of the obelisk*

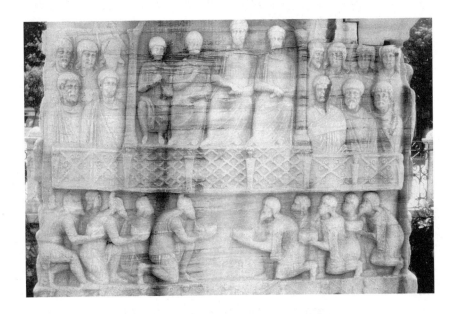

This column with four sides which lay in the earth only the
Emperor Constantine dared to lift again its burden. Proculus
was invited to execute his order and this great column stood
up in 32 days.

There is a discrepancy between the inscriptions in the number
of days that it took for obelisk to be erected, indicating that the
inscriptions were done by different people, and possibly not at the
same time.

Near the hippodrome were built some of the most splendid
churches in all Christendom, and for a thousand years they and
the obelisk survived. Then the empire decayed; Ottoman sultans
replaced the Christian emperors and churches were converted into
mosques. The obelisk remained as the only witness to the changing
religious and political climate that the following centuries brought.

As a postscript to this there was an interesting observation made
by the sixteenth-century traveller and writer Peter Gyllius (Gilles),
who said that, when he first arrived in Constantinople, he saw two
obelisks, one in the hippodrome and one standing upright in a
garden of the palace. Later he says that he saw it lying on the ground
and took measurements. He said that it 'was thirty-five feet long,
six feet square with a radius of twenty four feet' (*De Topographia
Constantinopoleus* (Leyden 1562): 84). He tells us that the obelisk
was purchased by Antonius Priolus, who sent it to Venice and placed
it in St Stephen's Market. Long, in his work *Egyptian Antiquities*
(1846: vol. 1, 332), says that this obelisk was made by Nectanebo
(378–360 BC), and was never actually removed from Istanbul
because it was identical to one that stood in the sultan's garden. The
inscriptions have never been published.

No further obelisks were to be removed from Egypt, for the
Roman Empire was on the verge of extinction. Nearly one and a half
millenia would pass before once again Egypt's treasures would be
removed by other emperors to adorn other empires.

CHAPTER 14

AN EGYPTIAN OBELISK IN FRANCE

A t the beginning of the nineteenth century, a surge of interest in ancient Egypt gripped Europe. However, this time it was not a Roman but a French emperor who was responsible for the removal of an obelisk.

When Napoleon Bonaparte came to Egypt on his military campaigns in 1798–1801, he brought with him a scientific expedition of scholars. They produced a colossal work, *Description de l'Egypte*, which gave the first complete survey of the country and its people since Strabo nearly two thousand years earlier. The work provided a detailed account of all the ancient monuments found, and included copies of all the hieroglyphic inscriptions recorded on them.

Serious academic interest in Egyptian history began when the French Egyptologist, Jean-François Champollion (1790–1832), discovered the key to deciphering the hieroglyphs. This information had a huge impact in Europe, and many European states began to seek and obtain Egyptian artefacts for themselves. People who held diplomatic posts in Egypt were soon employed in the acquisition of relics and 'persuaded' to obtain them by any means possible.

The governments of France and England were eager to obtain one or more obelisks to decorate their respective capital cities. Muhammad Ali, the ruler of Egypt, or rather the viceroy of the Turkish sultan, wanted to appease both countries, so he initially offered them the two obelisks of Tuthmosis III that then stood at Alexandria: the one still standing to go to France and the fallen one to go to England. The obelisks of the pharaoh Tuthmosis III were once the most numerous in Egypt; today none remains in the country. The American Egyptologist James Henry Breasted said of them:

Tuthmosis III erected a series of seven obelisks, of which five were in Thebes and two in Heliopolis. The latter now stand face to face on each side of the Atlantic, as they stood side by side at the portal of the Heliopolis temple. Of the five at Thebes, not one survives in Egypt; all having perished save two and these are now in Europe, one in the piazza of the Lateran in Rome, the other in Constantinople. We are thus presented with the surprising spectacle of the greatest of the pharaohs without a single surviving obelisk in the land he rules while the modern world possesses a line of them reaching from Constantinople to New York. (Breasted 1901: 55)

The two obelisks of Tuthmosis III that once stood at Heliopolis were the last to leave Egypt: in the end one was destined for the old world and one for the new. Originally they stood in front of the Temple of the Sun at Heliopolis and appear to have been erected by the first herald of the king, a man called Yamunedjeh, on the occasion of Tuthmosis' third jubilee, in his thirty-seventh year (c.1468 BC). They remained here for almost fifteen centuries before being taken by the Romans to Alexandria.

According to the Latin and Greek inscriptions on them, the obelisks were set up at Alexandria in 10 BC on the orders of the Emperor Augustus by his prefect Rubrius Barbarus and the architect Pontius. The obelisks stood in front of the Caesarium, the temple of the deified Julius Caesar, and rested upon bronze crabs, which carried the symbol of Sol, the Roman sun god. These crabs have been preserved and are now in the Metropolitan Museum of Art in New York).

In AD 1301, one of the pair fell down during an earthquake; this was the obelisk that Muhammad Ali later promised to London; the one that remained standing would eventually travel to New York. The obelisks had acquired the name of 'Cleopatra's Needles', although they had little to do with Cleopatra VII, the most famous queen of that name, having been erected at Alexandria some twenty-five years after her death. The Arab physician 'Abd-al-Latif, who

wrote at the end of the twelfth century AD, called them 'Pharaoh's Big Needles' (*misallati Fir'un*). The word *misallah* in Arabic means a big needle, the kind that packers use for sewing up bales, so we can understand the reasoning behind the name he chose. The fact that Cleopatra's name was attached is just a romantic gesture of association.

Before the obelisks' removal, France decided to ask instead for the pair that stood before the temple at Luxor. They had been promised to England sometime before, but, with the help of the British representative, the Luxor pair were finally ceded to France, while the obelisk of Hatshepsut at Karnak was offered to England as a replacement. Fortunately for Egypt, neither government was able to accept these offers because of the huge expense and trouble involved in moving them. Instead, each country made do with smaller artefacts, carrying their trophies away with relish.

It is said that the idea of moving an obelisk to France was originally the Emperor Napoleon's, although it never actually came to fruition in his lifetime. It is reported that Josephine's parting words to her husband [Napoleon] before he embarked on his Egyptian campaign were: 'Goodbye! If you get to Thebes, do send me a little obelisk.' Whether this is true or not, one thing is certain: it was this campaign that caused both France and Britain to turn their attention to the acquisition of obelisks—the British to commemorate their victory over France and the French to commemorate their scientific achievements.

The Place de la Concorde Obelisk (17)

The obelisk now sited in the Place de la Concorde in Paris (**17**) was one of a pair; its companion still remains in Luxor (**26**). Quarried from red granite, it is 22.5 metres (74ft) high, slightly smaller than the remaining one, and weighs 227 tonnes.

Its actual removal did not take place until 1814, ironically, when the French monarchy had been restored. Louis XVIII wanted to bring the obelisk to Paris to adorn his reclaimed capital (one is

reminded of Augustus' desire to do the same thing to legitimize his rule and establish a monarchy), and instructed his consul-general in Alexandria to approach the Pasha Muhammad Ali to see if this could be done. Immediately the Pasha said that he would give them the obelisk of Tuthmosis III that stood at Alexandria, as they had originally agreed, but that was as far as it went.

Champollion wrote to the minister of the navy and pointed out that the obelisks at Alexandria were uninspiring when compared to those at Thebes, and that if an obelisk was destined to be brought to Paris then it should be one from Luxor. Even before the Pasha had given his approval, plans were being made for the obelisk's removal. The Pasha's lack of interest in the history and monuments of his country, coupled with his eagerness to gratify all foreigners, meant that it was unlikely that he would object. A committee headed by the French minister of the navy was formed, and proposals for the removal of the obelisk were submitted. The committee sent Baron Taylor, a French writer of English descent, to gain final consent from the Pasha and also to acquire further antiquities for the collection in the Louvre. In a letter dated 25 November 1829, the minister of the navy asked the new king, Charles X, for approval for the mission, and, when this was granted, the delegates set off to Egypt, loaded with gifts for the Pasha and his son.

The Pasha found himself in something of a dilemma as he had already promised the two Luxor obelisks to the British. He did not receive the French delegation, who arrived in Egypt on 23 April 1830, until the following week. By this time he had made up his mind to give the French the Luxor obelisks and offer the British the standing obelisk of Hatshepsut at Karnak. However, as relations between the two countries were deteriorating, it was of paramount importance that the obelisks be removed as quickly as possible.

As soon as the project for bringing one of the obelisks from Egypt had been confirmed, the minister of the navy began preparations for building a ship to transport it back to France. The ship was called *Luxor* and was launched at Toulon on 26 July 1830. She set sail on 15 April 1831 and arrived at Alexandria on 3 May. At this point,

Champollion came up with another suggestion. According to him, the obelisk standing to the west of the entrance of the Luxor temple was the more beautiful one, and consequently should be the first to be removed; if time and money allowed, the other could follow.

The engineer responsible for the removal of the obelisk was Jean-Baptiste Apollinaire Le Bas (1797–1873). As the French consul-general was away, Le Bas' interview with the Pasha had to wait for a month. Le Bas wrote in his diary:

> At last, on 8 June my interview with Muhammad Ali took place in the presence of the consul-general. The governor [Muhammad Ali, the Pasha] who knew beforehand of my short stature, pretended not to have seen me when I was presented to him by the consul-general and asked, 'But where is your engineer? Tell him to sit beside me so that I may see him' [the French name Le Bas translates as 'the low one']. (Le Bas 1839: 28–9)

Le Bas goes on to say that the interview was quite successful and that Muhammad Ali promised him all the aid and resources he needed.

On 11 June, *Luxor* began her journey up the Nile, accompanied by a number of local boats carrying supplies. Low water hampered their progress and they did not reach Cairo until 27 June. The journey upstream was not without incident, which was fairly commonplace for all nineteenth-century travellers. Le Bas tells how, on his arrival at Qena, north of Luxor, he was received by the local *nazir* (chief), who was in charge of the town. He says:

> My surprise was extreme when I got out of the house, I was seized by the groom who perched me on a horse, whose enormous size contrasted in an unusual way with my small figure. My legs were almost horizontal. Since the position was extremely awkward, the chief of the grooms tried to convince me of the docility of the horse, by boasting that his master, aged and feeble though he was, could ride him while smoking his pipe. However, as a precaution, he placed

one of his men on each side of me to hold on to the bottom of my boots, and two others to hold on to the tail of the horse and its bridle, while four men carrying torches went in front. In such a procession I was conducted to the ship. Once there they gave me, as I expected, all signs of honour. For this I paid dearly, for one must tip all those who have shown such extreme signs of respect. In Egypt as well as in other countries, those who are empty handed are liable to be badly received. (Le Bas 1839: 41)

Luxor finally arrived at her destination on 13 August. Her bow was cut off so that the obelisk could be loaded. Local interest was aroused and the people could hardly believe these men were here to take away an obelisk in one piece. There were many difficulties still to be overcome. The town of Luxor was very different 250 years ago from what it is today. Houses had been built against the obelisks and the pylon, on top of 9 metres of accumulated debris. The interior of the temple was also filled with debris, and even more houses nestled there, as did the Mosque of Abu el-Haggag, with a plethora of small streets twisting through the tops of the temple's columns.

There were more than thirty houses standing around the obelisk and along the route needed to transport it to the ship. The owners of the houses were consulted and compensation paid for the destruction of their homes, so naturally it took some time to negotiate a satisfactory conclusion. The work finally began, but in the process a great deal of damage was done to the ancient buildings surrounding the obelisk.

Le Bas did not build a scaffold like Fontana had done three centuries before; instead, he used multiple sheers—two-legged lifting devices often used in shipyards—with the necessary pulleys and tackle. In the sweltering heat of temperatures often reaching 120 degrees Fahrenheit, houses were pulled down, earth was shifted, scaffolding erected and planks made for the obelisk to be loaded aboard ship. The sight must have been very similar to that in the days of the pharaohs, when the obelisk had first been erected.

However, there were more serious problems when a cholera epidemic swept the country. Many Europeans fled Luxor and, for those who remained behind, the non-arrival of the supply ships from Cairo resulted in many deaths. Finally, Le Bas and his colleagues achieved what Le Bas says was 'the removal from the ancient capital of the civilized world of one of its most beautiful pieces of decoration' (1839: 69).

The date set for the lowering of the obelisk was 23 October 1831. Waiting in their appointed places were 190 workmen, and when the rays of the sun hit the colossal statue of Ramses II, the men went into action. Within twenty-five minutes the obelisk had been inclined some 25 degrees, but this pace was hard to keep up and the obelisk was not finally lowered until 16 November. Once lowered, it had to be dragged onboard *Luxor*, which required considerable effort and was finally achieved on 19 December 1831, when the obelisk was placed safely onboard the ship. The local inhabitants did not believe that such a great feat could be achieved, and ran around exclaiming 'This is the work of Devils!' The governor of Upper Egypt, Sherif Bey, gave a more educated appraisal: 'I did not believe that it would be possible to transfer on board a ship such a considerable weight. The enterprise seemed to me unfeasible, and I can assure you that I was not the only person in Egypt of that opinion' (Le Bas 1839: 89).

On 25 August 1832, the waters of the Nile rose, allowing *Luxor* finally to sail downriver to Alexandria. After spending three months there, she left on 1 April 1833 and arrived in Toulon on 10 May. From Toulon the obelisk was transported in the autumn up the Seine to a point near the Pont de la Concorde in Paris.

Le Bas' task was not yet over: he still had to re-erect the monolith in the centre of the Place de la Concorde, the site chosen as its new home. While preparations were being made, the obelisk was placed on a cradle aboard *Luxor*, and the stone for the pavement and pedestal were set onboard. The obelisk and pedestal were soon put into position, and, on 24 October, 350 men of an artillery command assisted in the final stages of the operation. The obelisk and its cradle were suspended in the air by machinery, where it remained

until the following day. Early in the morning, crowds of spectators began to flock to the site, just as they had done in Rome in the days of Pope Sixtus V. More than 200,000 people packed into the Place de la Concorde and the avenues branching out from it. By noon King Louis-Philippe I and his queen arrived and took their places on the balcony of the Naval Ministry, overlooking the square. After three hours the obelisk was erected, to deafening applause from the assembled crowd.

On the sides of the pedestal cut in outline are representations of the apparatus used to erect the obelisk, alongside illustrations of its lowering and embarking; models of all the apparatus used were deposited in the Musée de Marine. The total cost of the operation is said to have been 2.5 million francs, which by today's calculation would be in the region of several million pounds.

The obelisk now stands in one of the most beautiful squares in the world, surrounded by fountains and overlooked by pavilions that house statues representing the great cities of France. It also provides a fitting terminus to the Champs Elysées. Its companion left behind at the Temple of Luxor does not stand in such splendid isolation. Describing the Luxor temple, now adorned by only one obelisk, Leslie Greener, the artist and historian of Egyptology, wryly remarked: 'Its imposing pylon gate will always have the bereft appearance of an elephant with one tusk missing' (1967: 160).

CHAPTER 15

OBELISKS IN BRITAIN

The Kingston Lacy Obelisk (20)

Nectanebus, one of the last native Egyptian kings, who reigned around the middle of the fourth century BC, rebuilt or founded a temple to Isis on the island of Philae, which lies at the southern end of the First Cataract, near Aswan. Later, the Ptolemies added to the temple, and sometime during the second century BC Ptolemy IX (116–107 BC) built a pylon with two figures of lions in front of it and set up a pair of red granite obelisks.

The explorer Belzoni visited the island in 1815 and noted that the lions had been badly damaged and that one of the obelisks had fallen and broken into pieces. The other obelisk he succeeded in removing from the island. No one in Egypt wanted the obelisk, so Belzoni sold it to W.J. Bankes of Kingston Lacy House, who transported it to England in 1821 and set it up in his park, where it stands today. The house and grounds are now in the care of the National Trust and open to visitors.

Bankes (1786–1855) was an antiquarian and scholar. In 1816, with the help of the Greek inscriptions on the obelisk pedestal, he was able to identify the cartouche that contains the name Cleopatra (Ptolemy IX's wife and not the famous Cleopatra VII). The obelisk stands nearly 7 metres (22ft) high and weighs approximately 6 tonnes. The *pyramidion* is without vignettes and in the centre of each face of the shaft is a column of hieroglyphs, recording that Ptolemy IX and his wife set up the obelisk in honour of the goddess Isis of Philae. The 2-metre (6ft) high pedestal on which the obelisk now stands has a metal plate that states that the obelisk was re-

erected in the park by Bankes in 1839, in the presence of the Duke
of Wellington.

Cleopatra's Needle, London (19)

The process of the removal of Cleopatra's Needle to London spans
almost three-quarters of a century. The story begins with the defeat
by the British under Lord Nelson of the Napoleonic fleet at the
Battle of Aboukir on 25 July 1799, and the French army's defeat
at Alexandria on 21 March 1801. The French were allowed to leave
Egypt, but the terms of the capitulation meant they were forced to
hand over certain antiquities.

The Earl of Cavan, who had been in charge of the British
contingent, decided to leave a record of the British victory, and
ordered an engraved plaque to be placed under the fallen obelisk of
Tuthmosis III at Alexandria. The plaque has never been discovered,
but may well surface during some of the excavation or building work
that is an everyday sight in modern Alexandria.

Both the earl and the soldiers who were serving under him
wished to send the fallen obelisk to England as a victory trophy.
The earl drew up plans, and the soldiers were asked to contribute
several days' pay to help with the expense of removal. The money
was willingly given, and work began on building a jetty to carry the
obelisk to a ship. The work came to a halt for some reason though,
and the obelisk remained in Alexandria until 1820.

On a personal visit to Egypt in 1820, Samuel Briggs, who had
been the British consul in Alexandria from 1803 to 1809, wrote to
the British government, saying that Muhammad Ali had consented
to the obelisk's release, offering it as a gift to King George IV. The
services of Belzoni were sought; he had already moved the obelisk
from the island of Philae to the Kingston Lacy estate in Dorset
(**20**). His services were secured, but still nothing happened with
the Alexandrian obelisk because Parliament refused to release the
resources to have it moved. In 1831 Muhammad Ali repeated his
offer, and even promised to have the obelisk removed at his own

expense to a ship that would carry it to Britain. This offer also fell on deaf ears.

Nevertheless, there were people in Britain who were enthusiastic about the project, including the politician and philosopher Joseph Hume (1775–1855). He finally managed to get serious discussions underway about the cost of such a project, and how best it might be accomplished. Once again the plans were foiled when serious protests about the condition of the obelisk were raised by a group of distinguished archaeologists, headed by the eminent Egyptologist Sir Gardner Wilkinson. When he heard that the project had been abandoned he said: 'The project has been wisely abandoned; and a cooler deliberation has pronounced that, from its mutilated state, and the obliteration of many of the hieroglyphics by exposure to the sea air, it is unworthy of the expense of removal' (Cooper 1877: 91).

Two years later, Hume proposed bringing the obelisk to London and setting it up in Hyde Park as a memorial of the great work that had been done by the Prince Consort in connection with the Great Exhibition of 1851; but this also resulted in failure.

In 1853 Joseph Bonomi was building the Egyptian Court at Sydenham for the Crystal Palace Company, and it was suggested that the obelisk should be brought to Britain and erected in the transept near the Egyptian Court, at an estimated cost of £7,000. The government granted permission for this, but told the company that although the company would bear the cost of the obelisk's removal, the obelisk would be the property of the nation and could only be lent to the company. The company decided against the project, to the great disappointment of the general public. So, once again nothing happened.

About fifteen years later, the governor of Egypt yet again raised the question of the removal of the obelisk to Britain. He had leased the land on which the obelisk stood to a Greek named Dimitri, who wanted to develop this property. His plans were being severely hampered by the obelisk's presence, so he applied to the Khedive to either have the obelisk removed or have it buried, so the Khedive requested that the British take their gift home.

Again no action was taken, until General James E. Alexander, a soldier and writer who had many influential contacts, finally took up the obelisk's cause. Having visited Paris in 1867 and seen the obelisk in the Place de la Concorde he wrote:

> I now determined to endeavour to save the national disgrace of the loss and destruction of the trophy . . . the prostrate obelisk . . . and resolved to do my utmost to have it transported to London, to grace the metropolis with a monument similar to those of Rome, Paris and Constantinople. (Noakes 1962: 16)

Even so, it was nearly ten years before Alexander's vision could be realized. He spent much time clearing the obelisk from the debris, and for seven years constantly bombarded the British government to act. He was urged on in his effort by rumours that reached him from Alexandria that a certain French engineer had offered to break up the obelisk for Dimitri.

Alexander was at the point of giving up hope when a chance meeting with a generous benefactor, a man called Erasmus Wilson—a retired physician—gave him fresh hope, and Wilson put up £10,000 or more for the obelisk's removal to the Thames Embankment. Finally, in 1875, Alexander went to Egypt and was given a special audience with the Khedive Ismail, the Egyptian ruler, who gave his permission for the obelisk to be removed.

The engineer chosen to carry out the task was John Dixon of the North England Company. He inspected the obelisk and cleared round it to determine its condition, which proved to be satisfactory, then he drew up a plan for its removal. The next step was to get permission from the owner of the land on which the obelisk stood. There were lengthy negotiations, as Dimitri was anxious to secure some recompense, either from the Egyptians for having to put up with the obelisk on his land, or from the British for removing it. How much compensation he actually received and from whom is not known, but—duly satisfied—Dimitri let the project go ahead.

The contract for the work between Alexander, Wilson and Smith was signed on 30 January 1876. A special barge to transport the

obelisk was designed by Dixon. It was divided into ten watertight compartments and resembled a giant boiler. When the work was completed, the barge was shipped to Alexandria in sections, to be rebuilt around the obelisk. Before the obelisk could be loaded onto the barge, the area around it had to be cleared, and the operation revealed many tombs and a plethora of artefacts. Houses and large stone blocks that stood en route to the sea were blasted away and a channel was dug from the obelisk to deep water.

The obelisk was placed inside the barge, which had been named *Cleopatra*, and was towed towards the harbour. The captain of the barge was Henry Carter, and he had a crew of five sailors and a carpenter. The steamship *Olga* towed *Cleopatra*, carrying the precious obelisk, to England on 21 September 1877.

From the very beginning, the trip was beset with difficulties. First there was extreme heat, followed by massive storms. Two crewmen were injured and had to be set ashore. Then, on 14/15 October, in the Bay of Biscay, more serious trouble overtook the two ships. John Dixon recounted what happened.

> It seems that on Sunday evening [14 October] the gale was so severe that the *Olga* cast off tow ropes and about 10 o'clock a tremendous sea overwhelmed the *Cleopatra*, broke some of the rail ballast adrift and left her with a strong list to starboard. Captain Carter, fearing that another such sea might capsize her, signalled for assistance. The *Olga* sent a boat with a volunteer crew, which found the *Cleopatra* and caught the ropes thrown to them, but could not hold on and drifted away. The *Olga* imagined her boat was with the *Cleopatra*. At daybreak, the gale continuing, a very skilful attempt was made to get the *Cleopatra*'s crew on board of the *Olga*. This proved successful, and it was then found that the boat's crew were missing, and the *Olga* steamed back to look after them. The search proved fruitless and on returning the *Cleopatra* could not be found, and the *Olga* at once headed for Falmouth. (Noakes 1962: 46)

Dixon insisted that *Cleopatra* would remain afloat until it was picked up by another ship, and he appealed to the First Lord of the Admiralty to send ships to seek it out and bring it to England. At the same time, a telegram was received from a Lloyds subagent in Spain, saying that *Cleopatra* had been picked up by a Glaswegian steamer, *Fitzmaurice*, owned by a Mr Burrell and had been towed into Ferrol in Spain.

This news was received with great pleasure, but there were many criticisms levelled at Dixon for timing the voyage in a season when storms were very likely in the Bay of Biscay. People were especially critical that so many lives had been lost because of this venture. Widows of the lost seamen received substantial sums of money by way of compensation; Queen Victoria suggested that the names of the dead should be carved on the base of the obelisk in remembrance.

The obelisk's troubles were still not over: Burrell, the owner of *Fitzmaurice*, demanded £5,000 salvage payment. Negotiations were speedily put in place as Burrell was definitely not to be persuaded that it was enough to have had the honour of rescuing the obelisk. He finally settled for £2,000, but when *Cleopatra* was returned almost everything else onboard the barge had also been 'salvaged'. Captain Carter lost his money, clothes, rare coins and jewellery, even his private letters, and—to add even more insult to injury—a mate from *Fitzmaurice* was seen to be parading around wearing the captain's shirt studs.

On 15 January 1878 the ship *Anglia* began to tow *Cleopatra* from Ferrol to England, reaching Gravesend on 21 January. On the 27th *Cleopatra* was brought up the Thames and moored in the East India Docks. The site of the obelisk's re-erection was finally decided upon, and on 30 May the obelisk at last reached its final resting place, near the Adelphi steps on the Embankment, between Waterloo and Charing Cross bridges.

A concrete base had been made, reaching down to the London clay beneath the mud bed of the river. *Cleopatra* was towed up from the East India Docks and brought alongside, and when the ship

was dismantled the obelisk was raised by hydraulic jacks and slid onto the Embankment. An iron jacket 6 metres (20ft) long with two projecting pivots on opposite sides was placed round the obelisk, with a stirrup strap to prevent it slipping when it was swung into a vertical position. It was then raised in a horizontal position by hydraulic jacks and supported on timbers as the raising proceeded.

The new base that had been made was adorned with four bronze plaques that recounted the history of the obelisk and the people who had been associated with it. The south face listed the names of those who had perished bringing it to London and reads:

> William Askin, James Gardiner, Joseph Benbow, Michael Burns, William Donald, William Patan. Perished in a bold attempt to succour the crew of the obelisk ship Cleopatra during the storm October 14th 1877.

Bronze castings of a pair of wings, intended to represent the wings from the Winged Disc of Horus of Edfu, were fixed at each corner of the base, and between each pair was a bronze casting bearing the prenomen of Tuthmosis III, Men-Kheper-Rā. Above the cartouche are the disc and the plumes of the sun god. On the right is a cobra, wearing the crown of the South and on the left is another cobra wearing the crown of the North. On the body of each cobra hangs the sign for eternity.

The obelisk is flanked by two bronze sphinxes, which are enlarged copies of a sphinx of Tuthmosis III preserved in the Egyptian collection of the Duke of Northumberland at Alnwick Castle. Each is about 5.5 metres (19ft) long, nearly 2 metres (6ft) wide and 3 metres (9ft) high and weighs about 7 tonnes. These models and castings were placed into position in September 1881. On the breast of each is the inscription, 'Beneficent god, Men-Kheper-Rā, giver of life'.

Without any public ceremony and in bad weather—almost as if in re-enacting the scene that had cost so many lives in its journey to London—the obelisk was finally erected on 13 September 1878. Thousands of people braved the wind and rain to see the stone being raised. The actual turning of the obelisk from a horizontal position

to a vertical one took about half an hour. The British and Turkish flags were run up, to a great roar of approval from the crowd. The obelisk was lowered into position on the pedestal. *The Times* carried the story, and reported:

> The enthusiasm of the crowd, as though the wonder they already saw before them had now for the first time struck them in all its grandeur, burst forth in ringing cheers, which were renewed from the river, road, terrace and bridge as the Union Jack was run up on the flagstaff which overtopped the *pyramidion* on the north side, and again the Egyptian [Turkish] flag followed on the south. These cheers for the colours were in honour of the Queen and Khedive; but the first burst was for Dixon and his coadjutors, and in recognition of a great triumph already won. (Noakes 1962: 91)

An interesting collection of objects was placed in the pedestal before the obelisk was set up, no doubt to fascinate and possibly confuse future antiquarians. These objects included: a bronze scale model of the obelisk two feet ten inches high, a piece of granite from the obelisk itself, a complete set of British money and a rupee, a standard foot and a standard pound, a two-foot rule, a standard gauge to the 1:1,000 part of an inch, a portrait of Queen Victoria, a history of the transport of the obelisk from Alexandria to London, with plans printed on vellum, Dr Birch's translation on parchment of the inscriptions on the obelisk, copies of the Bible in several languages, a translation of John 3: 16 printed in 215 languages, the Pentateuch in Hebrew, the Book of Genesis in Arabic, a copy of the *London Directory*, a copy of Whitaker's *Almanac*, a copy of Bradshaw's *Railway Guide*, a map of London, copies of current weekly and daily illustrated papers, a Tangye hydraulic jack and specimens of wire ropes and cables, a shilling razor made by Mappin, a box of cigars, a number of tobacco pipes, an Alexandra feeding bottle, a collection of toys, a box of hairpins and other toiletry articles used by women, and—perhaps most unusual of all—photographs of twelve pretty Englishwomen.

CHAPTER 16

FROM THE OLD WORLD TO THE NEW
AN OBELISK IN NEW YORK

The story of the removal of the other Alexandrian obelisk to New York (**21**) is less complicated than its companion's trip to London, and encompassed a shorter period of time. Khedive Ismail first offered the obelisk to the United States at the opening of the Suez Canal in 1869. The khedive suggested the idea to William Hurlbert, editor of the *New York World*, and Hurlbert became the driving force behind its removal.

The offer was not given a great deal of consideration by the United States until the London obelisk was removed, which aroused considerable interest. Negotiations went on for almost two years before an agreement was reached for the remaining standing obelisk in Alexandria to be removed. William Vanderbilt, son of the railroad baron Cornelius Vanderbilt, agreed to pay the costs, and Hurlbert put the job of removing and transporting the obelisk up for tender. Commander Henry H. Gorringe of the United States Navy won the bid and was given the task of directing operations. He recounted his mission and its ultimate success in his book *Egyptian Obelisks* (1882).

Problems began for Gorringe when an Italian consul in Alexandria claimed that the land on which the obelisk stood belonged to him and demanded payment for allowing Gorringe to set foot on his land. According to Gorringe's account, the only solution was to put the problem in the lap of the Egyptian government: 'I shall be compelled to telegraph my government', he told them, 'that I have been forcibly ejected, and the Egyptian authority has failed

to protect me' (Gorringe 1882: 23). The matter was resolved when the Italian consul was threatened with a claim for damages by the Egyptian authorities and he agreed to a settlement. There was a further delay when a creditor of the Egyptian government appealed to the international court to prevent any continuation of the work until his claim was also settled. To prevent any more claims arising, the America flag was hoisted on top of the obelisk to declare that this was officially the property of the United States, and finally the work on its removal could commence.

First, the ground around the obelisk had to be cleared to expose its foundations. Once again, as in the case of the London obelisk, many other antiquities came to light during the clearing work. Under the corners of the obelisk there had once been four bronze crabs, like those of the Vatican obelisk (5) only two remained, (now housed in the Metropolitan Museum in New York). On each of the crabs the original inscription was carved in Greek and Latin: 'In the eighteenth year of [Augustus] Caesar, [P. Rubrius] Barbarus, Prefect of Egypt, erected [it]; Pontius, architect'.

Once the site was cleared, Gorringe—in the presence of the governor of Alexandria and several hundred Egyptians and foreigners—brought the obelisk down from its pedestal and successfully lowered it onto a sort of caisson. To lower the obelisk, Gorringe had used a huge turning machine built by the firm of John A. Roeblings & Sons, which was used on the Brooklyn Bridge and had been shipped to Egypt specifically for the task. This mechanism essentially comprised two huge iron sawhorses with a pivot suspended between them that clamped onto the obelisk near its centre of gravity. The obelisk could be swung to a horizontal position, suspended 15 metres (50ft) in the air, and then gently lowered to the ground. The obelisk began pivoting, but it became stuck on one of the bronze crabs; once removed, it moved freely again. As the obelisk came down, a cable snapped and it started to fall but was prevented from doing so by a pile of timbers stacked up to catch it in just such an eventuality.

The obelisk was now stationary and horizontal, and was lowered

on a pair of hydraulic jacks at a rate of 1 metre (3ft) per hour. Finally, it was safely on the ground. Gorringe's plan was then to slide the obelisk on cannonballs resting on specially constructed rails to the harbour of Alexandria, about a mile away. As usual, though, there were obstacles.

The bankrupt Egyptian government had leased control of the streets of Alexandria to the foreign merchants who cleaned and repaired them. The merchants thought that the obelisk would do damage to the sewers and refused to let Gorringe move it through the streets. The only road that could be taken was very indirect and meant a great deal of extra effort and even greater expense. The pedestal and some of the underlying steps were removed, and the obelisk plus its container were transferred to the port via this route. Fortunately, the journey was completed without any mishaps.

The ship that was to carry the obelisk to the States was *Dessug*, built in England for the Postal Department of the Egyptian government. Alterations had been carried out to the steamer to strengthen it so that it could carry both the obelisk and the pedestal. The 50-tonne pedestal was loaded onboard at the port, but the obelisk had to be loaded in dry dock. An opening was made in the hull, and by means of two hydraulic jacks the obelisk was brought up to that level and pushed inside, onto a wooden platform designed to keep it steady throughout the voyage.

The obelisk was finally onboard and the steamer was ready to sail when there were further delays. First, it was impossible to find any men in Alexandria who were willing to man the ship and make the voyage. After some considerable time, a crew was finally enlisted in the city of Trieste on the Adriatic. Second, under US law the ship could not be registered as an American vessel, nor could she sail under the Egyptian flag because of 'serious risk and embarrassment' should the government's creditors confiscate the ship. Gorringe describes his solution to this problem in his book:

> There was no other course than open defiance of the law; which the circumstances fully justified; and I determined

to make the voyage from Alexandria to New York without registering the nationality; thereby taking the risk of having my steamer seized by any vessel of war at sea, or by the authorities of any port I might be obliged to touch at. (Gorringe 1882: 43)

Eventually, after a delay of several months, *Dessug* made its way to the New World.

The voyage was not uneventful, but nothing as disastrous as the incidents involving *Cleopatra* happened, and the ship finally anchored at the quarantine station of Staten Island on 20 July 1880. A site had not yet been finalized for the re-erection of the obelisk, and on the 27 July the Board of Commissioners of the Department of Parks decided that the obelisk should be set up on the summit of the Graywacke Knoll in Central Park, New York.

Before the obelisk could be conveyed there, the pedestal and its stepped foundation had to be transferred to the site. The foundation presented no problem, but moving the pedestal was a larger job. The colossal stone was removed from the steamer on 4 August and placed on the dock, then it was placed on a truck and dragged through the city streets by thirty-two horses, hitched in sixteen pairs. Gorringe wrote: 'This stone is the largest and heaviest ever moved on wheels of which there is any record, and excepting the obelisk it is the largest ever moved through New York' (1882: 43).

The foundation steps were laid down in Central Park in the same way that they had originally been done in Alexandria. On 9 October 1880, in a ceremony presided over by the Grand Master of the Masons in the state of New York, the pedestal was set in place. Gorringe was also a Freemason, and he linked the monument to the Masons' supposed ties to ancient Egypt. Some 9,000 uniformed Masons and 30,000 spectators witnessed the event.

The empty spaces beneath the steps were filled with various commemorative objects slightly less bizarre than the ones placed under the Thames obelisk. The Treasury Department donated a

set of proof 1880 coins; the War Department gave weather maps; the Anglo Saxon Masonic lodge No 137 contributed silver Masonic emblems; photographs of the obelisk's removal from Alexandria and 'Mr William Henry Hurlbert contributed a small box, the contents of which were known only to himself'. Strangely enough, there were no photographs of 'twelve beautiful New York ladies'.

All that now remained was the transferral of the obelisk from *Dessug* to the site in Central Park. There were many suggestions about the best place for the obelisk to be disembarked, and also the best route it could take to the site; finally they decided to disembark at Staten Island. The bow of *Dessug* was hauled out of the water at Luxor's Marine Railway on the eastern shore of the island, and the obelisk was removed from the ship. It was placed on pontoons and towed across the bay to Manhattan. Then it was taken through the streets of the city, travelling at the rate of 30 metres (100ft) a day. From 96th Street it went across to West Boulevard (Broadway), where it turned its first corner, which took six days to accomplish. Then it made its way slowly south to the East Side on 86th Street. Huge crowds turned out to see it make its way down Fifth Avenue and make its turn at 82nd Street into the park. It took 112 days to take the obelisk from its landing place to the site in Central Park, arriving there on 5 January 1881.

The Roeblings machine that had been used in Alexandria was reassembled in the park, fixed to the obelisk, and the trestle was dismantled, leaving the 220-tonne monolith suspended horizontally. The night before the obelisk was to be re-erected, Gorringe and half a dozen carefully selected workmen slipped quietly into the park and tested the turning mechanism, which worked perfectly.

The next day, the obelisk was raised, watched by a crowd of more than 10,000 people. Gorringe gave the signal, and the obelisk moved effortlessly to about a 45-degree angle. Then he ordered the movement stopped so that it could be photographed before he gave the final order to bring the obelisk into position. Gorringe recounts that moment:

This seemed to break the spell that bound the spectators in silence, and when the signal was given to continue the turning there arose a loud cheer that was prolonged until the shaft stood erect . . . It was to me an inexpressible relief to feel that my work was complete. And that no accident had happened that would make my countrymen regret that I had been entrusted with the work of removing and re-erecting in their metropolis one of the most famous monuments of the Old World. (Gorringe 1882: 50)

Only the formal presentation of the obelisk to the nation remained, and this was carried out on 22 February in the presence of many dignitaries and a crowd of 20,000. The ceremony was marked by a long speech by William Maxwell Evarts, the US Secretary of State. In the speech, Evarts thanked Egypt for the generous gift and acknowledged the efforts of Gorringe. It seems fitting that the obelisk that Tuthmosis III claimed 'mingled with sky' should now be situated in a city famed for its skyscrapers.

CHAPTER 17

THE OBELISK BUILDERS AND THE STANDING OBELISKS OF EGYPT

The Obelisk of Sesostris I (23)

Sesostris I, the second king of the twelfth Egyptian dynasty (1971–1928 BC), built a new temple in Heliopolis in honour of the sun god. In the twentieth century AD two fragments of this temple were found, having been reused in buildings in modern Cairo. Although the temple is almost completely destroyed, the plans and records of its construction survive in Berlin. A damaged leather roll once used by a scribe for writing practice has on one side a dedicatory inscription, which Sesostris I may have had carved upon a stele in his temple at Heliopolis. The scribe records the king's decision to build the temple for the god Harakhti in the third year of his reign (1968 BC). The second record is a plan of the temple, carved upon a thin piece of stone of which some fragments survive. The plan shows the temple with the additions made by later kings. On it the dimensions of the various parts of the temple are noted, and the people charged with the work are mentioned.

Only the obelisk still remains standing, but from the plan it is possible to establish the orientation of the temple, and that the surviving obelisk once stood to the right of its entrance. Today, the obelisk of Sesostris I is sited on the Cairo road, standing on a roundabout at the entrance to Heliopolis when approached from the direction of Cairo. This is the oldest surviving obelisk in the world, and its existence was known both to pagan and Christian writers. Saint Ephraim (fourth century AD), in his commentary on the thirty-third chapter of Isaiah, says that Heliopolis was the place

where the cult of devils and the worship of idols flourished. In this place, he says:

> There are two great columns which excite admiration. Each of them is 60 cubits high and stands on a pedestal 10 cubits high. The cap which rests on the top of each of these columns is of white copper, and its weight is 1,000 pounds or even more. On these columns are depicted figures of the men and animals which were shown by their priestly character to contain the mysteries of paganism. (Budge 1926: 84)

The figures representing the 'mysteries of paganism' were apparently on the copper caps, this being confirmed by an account of Maqrizi, an Arab historian of the fifteenth century AD. He said that the caps were like gold, and depicted on them was the figure of a man seated on a throne and facing the rising sun. Only this obelisk survives, its twin having fallen down at some point during the Middle Ages. The twelfth-century Arab historian 'Abd al-Latif gives a good account of them, describing them as square columns of pyramidal shape 100 cubits high.

The remaining obelisk carries a single column of inscriptions that is repeated on all four sides:

> Horus Ānkh-mestu. King of the South and North. Kheperkarā Lord of the Vulture Crown and Lord of the Uraeus Crown Ānkh-mestu. Son of Rā Userten I [Sesostris I] of the Souls of Anu [Heliopolis] beloved, living forever.
>
> The Golden Horus Ānkh-mestu the benevolent god Kheperkarā. [At the] time first of [celebrating?] the Set Festival. He made [these obelisks that] life might be given [to him] forever.

Since, as already mentioned, the Set festival traditionally marked the thirtieth jubilee of a king's reign, the monument was presumably erected for festivities in the year 1941 BC, Sesostris having come to the throne in 1971 BC.

The Theban Obelisks (24, 25, 26, 28)

Tuthmosis I was the son of Amenhotep I by his Queen Senseneb and ruled for about thirty years from 1546 BC. He was a great warrior who, not long after his coronation, began campaigns against the Nubians. After these victories in the south he went on to consolidate his power in Syria, where his armies conquered Shasu, a confederation of nomad tribes, and took possession of their country. Tuthmosis set up a stele at Ni, near the river Euphrates, to mark the extent of his kingdom in the north. The wealth acquired on these raids was spent building and repairing the temples of the great gods of Thebes and Abydos (Amun-Rā and Osiris). In an inscription found at Abydos, Tuthmosis boasts that he has made Egypt the first country in the world, and that his kingdom includes all the countries the sun encircles.

The largest Theban obelisks date from the eighteenth dynasty (1550–1307 BC), and some are still in situ. The majority originally stood in the two great temples of Karnak and Luxor; three remain standing today. Tuthmosis I, the dynasty's third king, erected a pair at Thebes, of which one is still standing (**24**). The other standing obelisks are those erected by his daughter Hatshepsut (**25**) and Ramses II (**26**) during a period that saw Egypt at the height of its power and prosperity.

Tuthmosis I built a court around the Temple of Amun-Rā in Thebes with a row of statues of Osiris, as well as a pylon (a majestic gateway leading to the temple) cut with reliefs and with grooves to hold flagstaffs, and another entrance with a copper door on which a figure of the god was inlaid with gold. In front of the pylon he set up a series of flagstaffs, covering their tops with shining refined copper. He had two obelisks quarried at Aswan and built a ship 60.5 metres (200ft) long and 18 metres (60ft) wide on which to transport them to Thebes. According to Budge, Tuthmosis I's actions seem to show that he was favourably disposed to the priesthood of Heliopolis that united the cult of Rā with the Theban god Amun.

Just as Sesostris I had set up a pair of obelisks before the house of Rā at Heliopolis, so Tuthmosis I set up his pair before a pylon of the Temple of Amun (Budge 1926: 93). They were erected under the direction of an official named Anni and both pylons were linked by a colonnade that was still standing in the eighteenth century when the traveller Richard Pococke (1704–65) visited Thebes.

One of the Theban pair erected by Tuthmosis I still stands in the court at Karnak (**24**); parts of the second can be seen lying on the ground near to its surviving pedestal. The standing one is 19.5 metres (90ft) high and weighs 143 tonnes. On the west face the inscription tells us that Tuthmosis: 'made it as a monument for his father Amun-Rā, of the Two Lands, erecting for him two large obelisks at the double gate of the temple, the *pyramidions* being of electrum'.

On the pieces of the fallen obelisk, the cartouches of Tuthmosis III are found, and this has led some scholars to argue that Tuthmosis III was responsible for its erection. However, the inscription on the one still standing clearly states that Tuthmosis I set up both. It seems likely Tuthmosis I died before his inscriptions were cut on the second obelisk and so Tuthmosis III usurped it. The sides of the *pyramidion* of the standing obelisk are uninscribed, but may have originally been furnished with an inscribed copper cap, like those of Sesostris I at Heliopolis.

Hatshepsut's Obelisk (25)

When Tuthmosis II died, in the fifteenth century BC, his son by a minor wife succeeded him. Hatshepsut was regent to this young king, Tuthmosis III, but early in his reign she proclaimed herself 'king' and reduced him to the rank of co-regent. During her reign, Hatshepsut was represented wearing the traditional artificial beard and was often referred to by a masculine pronoun. For a queen to proclaim herself ruler while a legitimate heir sat on the throne was unprecedented, so—in order that the people and priesthood might accept her as ruler—she placated them by erecting great

monuments and publicizing her achievements in Egypt and Nubia, doing so at Thebes in particular.

In the Temple of Amun-Rā at Karnak she erected a huge sanctuary surrounded by subsidiary chambers, and set up two pairs of obelisks near by. Unfortunately, few of these structures survived her death. During his sole reign, Tuthmosis III destroyed them and erased Hatshepsut's name and image, replacing it in some cases with that of Tuthmosis I, II or III.

Only one of the two pairs erected by Hatshepsut now survives (25): one of a pair erected on the occasion of the jubilee of the fifteenth year of her reign. The pair was set up to the east of those raised by her father, in the area behind the fourth pylon, beside the 'noble gateway of Amun Great of Awe'; the lower part of one obelisk remains resting on its base, the other is fully standing.

The standing obelisk is made of red granite and is 29.5 metres (97ft) high, weighing 323 tons. Unlike earlier examples, these two had on the upper half of each face eight scenes, either side of the usual column of inscriptions. Each scene showed the figure of the queen or her stepson Tuthmosis III in poses representing adoration or making offerings to Amun-Rā. These scenes and the *pyramidion* were covered with electrum, which would have made almost the entire upper half of the monuments gleam in the sunlight.

On the sides of the base of the standing monument is cut an inscription thirty-two lines long, in which Hatshepsut sets out her full titles and explains her reasons for making the obelisks. She gives their history and addresses her people, both the living and those yet to be born. Hatshepsut adopted a fourfold name, as her predecessors did, but she added the title 'Khnemit of Amun' (counterpart of Amun), asserting that she was begotten of Amun and that the substance of her body was identical in every respect to that of the god. She claims that the self-created god Ari-su created her, and in her soul and body she possessed the attributes of all the other great gods. She believed she was 'God of All' in the form of a woman, and by obeying Amun she was not only worshipping him

but herself as his counterpart. The inscription is both important and interesting and is given in full in the Appendix.

When Hatshepsut died in 1458 BC, Tuthmosis III (1479–1425 BC) soon showed his talents as a warrior, builder and administrator. Under his rule, government became highly centralized, giving Tuthmosis the freedom to campaign against foreign territories. More buildings were erected under his auspices than under previous kings, and he set up at least seven obelisks in Karnak and two in Heliopolis, though none of them still stands in its original location. The obelisks appear to have been erected to celebrate the first five jubilee years (the thirtieth, thirty-fourth, thirty-seventh, fortieth and forty-third) of his reign.

Six of the obelisks that he erected were made under the supervision of the first herald of the king, a man named Yamunedjeh, who left a rock inscription on the island of Seheil, near Aswan. In his tomb, this official boasted that he had witnessed the erection of two pairs of obelisks in honour of Amun and a third pair in honour of Aten, lord of Heliopolis. One pair stood to the south of the seventh pylon, the upper part of which is now in Istanbul (**16**), while fragments of its companion remain at Karnak. The second pair of obelisks stood to the west of the obelisk belonging to Tuthmosis I (**24**). The pedestals of these two were unearthed in the 1970s from beneath the foundations of the third pylon. The placement of the third pair is unknown.

It is the seventh and last of these obelisks originally erected at Karnak by Tuthmosis III that is the largest single surviving one, standing 36 metres (119ft) high. Only its foundation remains in the eastern part of the Great Temple in Karnak. The base is lost and the shaft was removed to Rome, where it now stands in the Piazza San Giovanni in Laterano (**13**). The inscription on it makes reference to the fact it was erected as a solitary obelisk, though why this was so is not clear.

Inscriptions on the buildings of Tuthmosis III record his achievements as Egypt's greatest military leader, with an impressive

seventeen campaigns against the Hittite kings of Asia Minor and the Mitanni (Medes) of the Euphrates Valley. His conquests were followed by a period of consolidation and inter-marriage between the Egyptian royal family and the royal families of the Hittites and Mitanni. A time of peace and prosperity followed, which allowed the rulers to transfer their attention to religion and monumental projects designed to perpetuate their names for posterity and ensure the continuing benevolence of their many gods.

The Luxor (Cairo) Obelisk (27)

Ramses II was one of longest-lived pharaohs of Egypt, dying at the grand age of ninety-six. He had accompanied his father on military campaigns at the age of only fourteen and in Seti I's (1306–1274 BC) seventh year he was named co-ruler. At the age of twenty-two he undertook a campaign in Nubia, accompanied by two of his own sons, (he eventually had ninety-six in total, and outlived all but one of them). With his own father he also began vast restoration projects up and down the Nile: they built a new palace at Avaris and opened or refurbished wells, quarries and mines.

On the death of Seti I in 1274 BC, Ramses II set about restoring the Egyptian Empire, beginning a series of wars against the Syrians, and winning the Battle of Kadesh, immortalized in a poem inscribed upon the temple walls. Ramses II thus brought to a successful conclusion the Syrian wars that had plagued the final years of Seti's reign. The great wealth that flowed into Egypt, coupled with the extraordinarily long reign of Ramses II (1290–1224), meant his massive building programme far surpassed those of all his predecessors.

The largest obelisks to be erected by Ramses II were at Thebes in the temple of Luxor. Only one of the pair now remains in situ before the pylon gate (**26**); its companion resides in Paris (**17**). The Luxor obelisk is of red granite and is 25 metres (82ft) high and weighs approximately 254 tonnes. It stands on a huge pedestal with four large baboons depicted on both the front and back of

the shaft; each baboon has its forelegs raised in adoration of the sun. On the top of each side of the shaft are representations of the king making offerings to Amun-Rā and below are three columns of inscriptions, over half of each column containing names and titles of the pharaoh.

The text on the north or front face has no reference to any particular event or festival. The centre column of the inscription has the usual dedication similar that of its companion. On the right side the inscription refers to 'Ramses splendid of Statues, great of monuments in the Southern Opet [Luxor] ... making monuments in Thebes and for the One'. The column on the left side calls Ramses 'the sovereign, great of Jubilees like Tatenen, making monuments in Karnak for his father Amun-Rā who placed him upon his throne'.

None of the obelisks erected by Ramses II survives at Karnak, but outside the *temenos* (boundary) wall at the eastern gateway are the remains of two pedestals, along with small fragments that bear the name of Ramses.

The Obelisk of Ramses II in Cairo (27)

Because the Ramesside kings of the nineteenth and twentieth dynasties came from the eastern part of the Nile Delta, they took Tanis (Avaris) as their personal capital, the city that the earlier Hyksos invaders had also chosen. This capital came to special prominence during the reign of Ramses II, who chose it to be the capital of all Egypt and renamed it Piramesses-Meramun (the domain of Ramses, beloved of Amun). In this city, Ramses constructed palaces, villas, barracks, workshops and innumerable temples. The temples were not just dedicated to the main Egyptian gods but also to the local gods of the various districts of Egypt; foreign cults were not excluded. This new capital cannot be accurately located today, though most scholars agree that the ruins of the ancient city of Piramesses now lie under and around the village of Qantir, some 30 kilometres south of Tanis.

Twenty-three obelisks, or fragments of them, have been unearthed at Tanis, all but one inscribed with the name of Ramses II, though not all may have been made by him. They have found their way to various destinations and are in museums throughout the world (Britain, Poland and Germany in particular). Only one remains standing in Egypt (**27**).

Egypt's modern capital, Cairo, had no monument from the pharaonic period, and so it was decided in 1958 to move a colossal statue of Ramses from Memphis and an obelisk from Tanis. The latter was placed in the Al Andalus Garden on Gezira Island. It is 13.5 metres (44½ft) high and rests on a high modern pedestal, near to the modern Cairo Tower. On each face of the obelisk is a column of inscriptions describing the warlike attributes of Ramses II: the west face has 'The king son of Ptah who is pleased with victory', south has 'The one who seizes all lands', east has 'A Monthu among kings who attacks hundreds of thousands', and north 'The king who smites every land'.

The Obelisk of Seti II at Karnak (28)

Seti (or Sethos) II (1207–1202 BC) was the grandson of Ramses II and son of Merneptah. He erected a small pair of quartzite obelisks 100 metres to the west of the first pylon of the Great Temple of Amun at Karnak, in front of the avenue of the sphinxes on the right side; one of these obelisks remains standing (**28**). The inscriptions are unimpressive, consisting of the names of Seti II repeated over and over. The obelisk's appearance is similarly underwhelming when compared to those of his predecessors. It is just over 7 metres (23ft) high and in poor condition, and often goes unnoticed by the army of tourists that visit Karnak annually.

CONCLUSIONS

I n ancient times the erection of these monuments must have been a time for great rejoicing and ceremony. Their visual splendour—great shafts of light—would have impressively adorned the capitals of ancient Egypt. It is little wonder, therefore, that when invading armies conquered Egypt they sought to establish their right to rule the land by carrying off pieces of these valuable items as symbols of power and authority.

It was many hundreds of years later, when Egypt became part of the Roman Empire, that the lowering, transportation over enormous distances and re-erection of these colossal monuments happened on an unprecedented scale. This movement itself was a feat to rival even the achievements of the ancient Egyptians who had originally created and erected the obelisks. The obelisks stood as a testimony to the power of Rome, but on the collapse of the empire they were left to fall into ruin. Some fifteen hundred years would pass before they came to the attention of the papacy and a fresh interest was aroused. Popes Sixtus V was their patron and he decided that the obelisks would most fittingly serve as 'signposts' to the various religious sites throughout the city.

Because of the pope's intervention, these stones are standing today: each year, hundreds of thousands of visitors flock to the Eternal City, once again pilgrims use the obelisks as markers to the various sites. At the Piazza Navona, tourists and locals soak up the atmosphere of the square, sitting around the fountain that is adorned by Bellini statues; they do likewise at the foot of the Spanish Steps, one of the most picturesque sites in Rome. The masses of people seem to be unaware of the towering sentinels of

antiquity that look down on them, and strangely the obelisks often go unnoticed. Yet each obelisk has a fascinating history to tell that demonstrates the power that these monoliths have to influence the political and personal agendas of different generations of rulers over the civilized world. They should receive the recognition due to them.

An obelisk was involved in the conflict between Ethiopia and Italy during the 1930s: when Italy invaded Ethiopia, it removed an Ethiopian obelisk from one of its ancient capitals, Axum, known for its outstanding architecture. Axum was regarded as one of the four great capitals cities of antiquity, and this obelisk had been erected by King Ezana of Axum in AD 325, when he converted to Christianity.

In January 2005 the *Guardian* newspaper reported that the authorities in the Ethiopian capital Addis Ababa claimed that money had now been found to transport the obelisk from Rome back to Axum in May of that year. The obelisk was taken apart, ready for shipping back to Ethiopia, but lack of finance from the Italian government—who had agreed to underwrite the cost—stalled proceedings, and from July 2004 until April 2005 the obelisk lay under tarpaulins at the back of a police barracks. It seems that the modern world has even greater difficulty in transporting these monuments than its ancient counterpart. According to the *Guardian:*

> The problem is to find a plane big enough to carry the vast granite chunks back to Axum . . . According to one estimate the heaviest cargo that could be safely landed on the airstrip [which has been built at Axum specifically for this task] would be fifty-five tonnes; the obelisk's heaviest segment is eighty-seven tonnes. (*Guardian*, 3 January 2005)

In this light the Roman emperors' achievements are even more remarkable.

Finally, the obelisk was safely transported, and on 4 September 2008, it was re-erected in the capital Addis Ababa, to much rejoicing from the inhabitants.

The future of the obelisks may appear secure, but by far the biggest threat to their continued existence is pollution. Modern cities erode the stone—the New York obelisk, for example, has deteriorated badly in its new environment— and we cannot take their continued presence for granted.

Perhaps the final words on obelisks should be left to William Maxwell Evarts, the US Secretary of State. In his speech at the erection ceremony of the New York obelisk he concluded by saying:

> Who indeed can tell what our nation will do if any perversity is possible of realization; and yet this obelisk may ask us, 'Can you expect to flourish forever? Can you expect wealth to accumulate and man not decay? Can you think that the soft folds of luxury are to wrap themselves closer and closer around this nation and the pith and vigour of its manhood know no decay? Can it creep over you and yet the nation know no decrepitude?' These are questions that may be answered in time of the obelisk but not in ours. (Gorringe 1882: 53)

APPENDIX

TRANSLATIONS OF TWO OBELISK INSCRIPTIONS

I t is not possible, neither is it warranted, to give a list of all the obelisk inscriptions. For those interested, they can be found in J. Breasted's *Ancient Records of Egypt*. However, two inscriptions have been selected for inclusion here because they are unique and deserve special mention.

Inscription on the Base of the Obelisk of Hatshepsut (25)

The first set of inscriptions is to be found on the base of the obelisk of Hatshepsut. Hatshepsut was one of the most remarkable pharaohs, not least because she was the first female pharaoh and managed to hold onto the throne for fifteen years. Her rule was a prosperous period in Egyptian history, and peace reigned throughout the kingdom. When she died, the tribunes of Egypt in Western Asia refused to pay tribute to the new pharaoh, Tuthmosis III.

Hatshepsut was probably responsible for ordering the largest obelisk ever quarried, which still remains in situ in Aswan. Perhaps more important is that, on the obelisk inscriptions that survive, she styles herself Khnemit of Amen, in other words she declares that she was begotten by Amen and that she is his female counterpart. No other pharaoh ever made this claim. Hatshepsut believed that she was 'god of all' in the form of a woman, and aside from the archaeological value of such an inscription, it is significant evidence for a definite change in ideology.

South Side

The living Horus Useritkau. Nebti Uatchit Renput. Golden Horus
Neterit Khāu Nesu-bat Maāt-ka-Rā Hashepsut-Khnemit Amun,
living forever and ever. Daughter of Amun-Rā, darling of his heart,
one and only existing through him, glorious essence of Nebertcher
[Lord of the Universe], her beauty was created by the spirits of Anu,
the conquerers of the Two Lands, like Ari-su [whom] he created to
wear his crowns, creatress of many forms like Khepera diademed
with diadems like the god of the Two Horizons, the holy egg, the
glorious offspring, the suckling of the two goddesses of great
magical powers, the one raised up by Amun himself upon his throne
in Southern Anu, the one chosen by him to shepherd Egypt, to hold
in check the Pat and the Rekhit [two classes of Egyptian people],
the Horus woman who avenges her father, the eldest daughter of
Kamutef, the woman begotten by Rā to make for him a glorious
posterity on earth to protect the Henmemit [perhaps a class of
people], his living image, King of the South and the North, Maāt-
Ka-Rā the woman who is the *tchām* of kings. She made [them] as
a monument to her father, Amun, Lord of the Thrones of the Two
Lands, President of the Apts. She made for him two great obelisks
of the lasting granite of the region of the South. The upper parts of
them are of *tchām* of the best of all the mountains and they can be
seen [on both sides of the river]. The two lands are bathed in light
when Aten [the solar disc] rolls up between them as he rises up on
the horizon of heaven. I have done this because of [my] loving heart
for father Amun. I went in at his advance on the first day [of the
festival?]. I acquired knowledge from his skilled spirits. I hesitated
not on any occasion when he commanded.

West Side

My majesty understands his divine power and behold I worked
under his direction; he was my leader. I was unable to think out
a plan for work without his prompting; he was the giver of the

instructions. I was unable to sleep because of his temple. I never turned aside from any order which he gave. My heart was like Sia [god of knowledge] in respect of my father [Amun]. I entered into the plans of his heart in no way did I neglect the city of Nebertcher but set it before my face. I know that the Apts are the horizon upon the earth, the holy stepped building of the first day [primeval time], the eye of Nebertcher, the seat of his heart, the support of his beauties, the bond of those who follow him.

The king [Hatshepsut] said: I have set [these obelisks] before the people who shall come into being two hen periods [120 years] hence, whose minds shall enquire about this monument which I have made for my father, who shall speak with awestruck voices and shall seek to gaze into what is to come later. I took my seat in the Great House, I remembered him that created me.

My heart urged me to make for him two obelisks with *tchām* coverings, the *pyramidia* of which should piece the sky in the august colonnade between the two great pylons of the KING, the mighty bull, the King of the South and the North, Ā-Kheper-ka-Rā, the hours, whose voice [speaks] truth. Behold my heart [or mind] took possession [or overcame] me, leading me to utter words.

O you men of understanding.

North Side

Who shall look upon my monument after years who shall discuss together what I have done, take heed that you say not 'I know not [why] these were made and [why] a mountain was made throughout in gold,' as if it was one of the commonest things that exist. I swear that as Rā loves me, and as my father Amun has shown me favour, and as the child of my nostrils is with life and serenity; and as I bear the white crown and am crowned with the red crown and have joined together for the two hawk gods their divisions of the world have governed this land like the son of Isis and am mighty lie the son of Nut; and as Ra sets in the Sekhet boat in the evening and appears joyfully in the Atet boat in the morning and joins his two

mothers in the boat of the god and as heaven is stabilised firmly, and as what he [Rā] has made is stable I shall have my being for ever and ever like an An-sek-f star I shall sink to rest in [the land of life] like Atem, so these two great obelisks which my Majesty has worked with *tchām* for you father Amun, in order that my name may abide and flourish forever. Each obelisk is made from a single block of granite in the quarry without cleavage, without division. My Majesty demanded work thereon from the first day of the second month of the season Pert of the fifteenth year [of my reign] until the last day of the fourth month of the season Shemut of the sixteenth year of my reign making seven months since my demand in the mountain.

East Side

I made [them] for him in rectitude of heart for [he is] thinking of every god. I longed to make them for him, plated(?) with *tchām* metal; lo! I laid their part [or half] upon their bodies. I kept in mind [what] the people would say: that my mouth was true because of what came forth from it, for I never went back on anything that I had once said. Now listen to me. I gave to them [the obelisks] the best refined *tchām* which I measured by the heket as if I had ordinary grain in sacks. My majesty allotted to them a larger quantity of *tchām* than had ever been seen by the whole of the Two Lands. This the fool as well as the wise man knows well. Let not the man who shall hear these things say what I have said is false, but rather let him say, it is even as she has said it: true before her father. The god knew it [was] in me and Amun Lord of the Thrones of the Two Lands caused me to be Governor of Kamt and Teshert as a reward for it. None rebel against me in all the lands, the dwellers in the mountains and deserts are my subjects. He has fixed the boundary of my kingdom as far as the limits of the sky, the circuit of Aten serves me, he has bestowed it upon me, living through him, I present it to him. I am his daughter in very truth, the glorifier of him . . . what he arranged, the vessel of my body is with my father,

life, stability, and serenity upon the throne of hours of all living beings like Rā forever.

The Flaminian Obelisk in the Piazza del Popolo (2)

The other inscriptions that are worth giving in full are to be found on the obelisk erected by the Emperor Augustus, which now stands in the Piazza del Popolo. The translation in antiquity of the Egyptian hieroglyphs clearly demonstrates the ideology that was employed by Augustus to secure his right to rule. The two sets of translations, Egyptian and Greek are given here so that the reader may make comparisons.

The inscriptions of Seti on the three sides read:

North Side

Horus [name], mighty bull, resting on truth. Nebti [name] Menthu of the Two Lands [Egypt], Protector of Egypt. Golden Horus [name] Chief, divine, of Khepera. Nesubati [name] Men-maāt-Rā, making splendid monuments in Anu, the everlasting seat, which is more firmly founded than the four pillars of the heavens, more stable and flourishing than the forecourt of the House of Rā. The company of the gods are satisfied with what has made the son of Rā, Set Mer-en-Ptah, beloved of the souls of Anu, like Rā.

South Side

Horus [name] mighty bull, trampler on all countries in his strength. Nebti [name] stabilizer of monuments for ever and for ever. Golden Horus [name] Satisfying Rā with his [works of] love. Nesubati Men-maāt-Rā, the august one of Anu dweller in . . . pourer of libations to Rā, Lord of the . . . The lords of heaven and of earth rejoice and are glad in [showing] him favours and make double what they do for him. The son of Rā, Seti Mer-en-Ptah, beloved of Her-aakhuti works like Rā forever.

On the same side is a vignette in which Seti is seen offering two vases to the god. The king is described as:

Horus, mighty bull, life of the Two Lands, Lord of the Two Lands, maker of things, lord of valour, Men-maāt-Rā, son of Rā, of his body, beloved by him, lord of crowns, Seti Mer-en-Ptah, beloved of Rā the great god, lord of heaven, dweller in the Great House. And Her-aakhuti, the splendour of the Two Lands, the great god, the lord of heaven says 'I have given to you all lands and all hills and deserts in peace. I unite for you on the throne of Horus the South and the North of Egypt like Rā forever.'

West Side

Bull of Rā, beloved of Maāt, fetterer of countries, vanquisher of the Mentiu, beloved of Rā, making great his ka, Men-maāt-Rā, who fills Anu with obelisks, so that their rays may rise upon the House of Rā and flood it with his splendours, and that the gods may assemble in the Great House joyfully. The son of Rā, Seti Mer-en-Ptah, beloved of the company of the gods who dwell in the Great House did [this] that life might be given to him.

The vignette on the pyramidion and the three columns of text on the east side were the work of Ramses II. The following three lines give an idea of the remaining inscriptions of Ramses II that are found on the obelisk.

Centre

Mighty bull beloved of Maāt, User-maāt-Rā Setep-en-Rā, son of Rā, Rāmessu meri-Amun, made his monuments [as numerous] as the stars of heaven. His works join themselves to the height of heaven, Rā shines on them and rejoices over them in his house of millions of years. His Majesty [Ramses II] beautified this monument of his father so that he might make his name to be stabilized in the House of Rā. The son of Rā Rāmessu meri-Amun, beloved of Tem, Lord of Anu, did this so that life might be given to him forever.

Left

Horus, mighty bull, beloved of Maāt, strong in years, mighty one of victories, King of the South and the North, User-maāt- Rā setep-en-Rā, son of Rā, Rāmessu meri-Amun has made Anu splendid by his great monuments, sculpting the gods in their forms in the Great House. To the Lord of the Two Lands, User-maāt-Rā setep-en-Rā, son of Rā, Rāmessu meri-Amun, may life be given forever.

Right

Horus, mighty bull, beloved of Maāt, fashioner of the gods, Landlord of the Two Lands, King of the South and the North User-maāt-Rā setep-en-Rā, son of Rā, Rāmessu meri-Amun. The rays of the Two Horizons rejoice when they see what has done the Lord of the Two Lands, User-maāt-Rā setep-en-Rā, son of Rā, Rāmessu meri-Amun, to whom life has been given like Rā.

Translation of the Greek text produced by the Egyptian priest Hermapion for Augustus, as given in the fourth century AD by Ammianus Marcellinus in his History *(see p. 55).*

South Side

The sun speaks to King Ramestes. I have granted to you that you should with joy rule over the whole earth, you whom the sun loves and powerful Apollo, lover of truth, son of Heron, god-born, creator of the world, whom the sun has chosen, the doughty son of Mars, King Ramestes. To him the whole earth is made subject through his valour and boldness. King Ramestes, eternal child of the sun.

South Side Second Line

Mighty Apollo seated upon truth, Lord of the Diadem, who has gloriously honoured Egypt as his peculiar possession, who has beautified Heliopolis, created the rest of the world, and adorned with manifold honours the gods erected in Heliopolis he whom the sun loves.

South Side Third Line

Mighty Apollo, child of the sun, all radiant whom the sun has chosen and valiant Mars endowed; whose blessings shall endure forever; whom Ammon loves as having filled his temple with the good fruits of the date palm; to whom the gods have given length of life. Apollo, mighty son of Heron, Ramestes, King of the World, who has preserved Egypt by conquering other nations; whom the sun loves; to whom the gods have granted length of life; Lord of the World, Ramestes, ever living.

West Side Second Line

The sun, great god, lord of heaven; I have granted to you life hitherto unforeseen. Apollo the mighty, lord incomparable of the diadem, who has set up statues of the gods in this kingdom, ruler of Egypt, and he adorned Heliopolis just as he did the sun himself, ruler of heaven; he finished a good work, child of the sun, the king ever-living.

West Side Third Line

The god sun, Lord of Heaven, to Ramestes the king. I have granted to you the rule and the authority over all men; whom Apollo, lover of truth, lord of seasons, and Vulcan, father of the gods, has chosen for Mars. King all-gladdening, child of the sun and beloved of the sun.

East Side First Line

The great god of Heliopolis, heavenly, mighty Apollo, son of heron, whom the sun has loved, whom the gods have honoured, the ruler over all the earth, whom the sun has chosen, a king valiant for Mars, whom Ammon loves, and he that is all radiant, having set apart the king eternal: etc.

BIBLIOGRAPHY

Arnold, D. (2003) *The Encyclopaedia of Ancient Egyptian Architecture* (London: Taurus Press).

Bagnell, R.S. and Rathbone, D.W (eds) (2004) *Egypt from Alexander to the Copts: An Archaeological Guide* (London: British Museum Press).

Barrett, A. (1989) *Caligula: The Corruption of Power* (London: Routledge).

Barton, T. (1994) *Ancient Astrology* (London: Routledge).

Betz, H.D. (1985) *The Greek Magical Papyri in Translation* (Chicago: Chicago University Press)

Birley, A. (1997) *Hadrian: The Restless Emperor* (London: Routledge).

Birch, S. (1852–53) 'Obelisk of the Lateran: Notes on Obelisks', *Records of the Past* 4: 9.

Breasted, J.H. (1906) *Ancient Records of Egypt*, 5 vols (Chicago: University of Chicago Press).

Briar, B. (2002) 'The Saga of Cleopatra's Needles', *Archaeology* November–December: 48–54.

Budge, E.A. Wallis (1926; reprinted 1990) *Cleopatra's Needles and Other Egyptian Obelisks* (New York: Dover).

Chevrier, H. (1970) 'Technique de la construction dans l'ancienne Égypte. II Problèmes posés par les obélisques', *Revue d'Égyptologie* 22: 15–39.

Claridge, A.M. (1998) *Rome: Oxford Archaeological Guides* (Oxford: Oxford University Press).

Cooper, R. (1877) *A Short History of Egyptian Obelisks* (London: S. Bagster & Sons).

Corpus Inscriptionum Latinarum (CIL) (1853–) Berlin: Berlin-Brandenburg Academy of Sciences and Humanities)

Dibner, B. (1970) *Moving the Obelisks* (Cambridge, MA: MIT Press).

Eck, W. (2003) *The Age of Augustus* (London: Blackwell).

Engelbach, R. (1922) *The Aswan Obelisk* (Cairo: Institut français d'archéologie orientale).

Engelbach, R. (1923) *The Problems of the Obelisk* (New York: George Doran).

Erman, A. (1896) 'Die Obelisken der Kaiserzeit', *Aeg. Zeit* 34: 149–50.

Faulkner, R.O. (1969) *The Ancient Egyptian Pyramid Texts* (Oxford: Clarendon).

Fontana, D. (1590) *Della Trasportatione dell' Obelisco Vaticano ed delle Fabriche di Nostro Signore Papa Sisto V* (Rome: Libro primo con tavole).

Garis Davies, N. de (1933) 'The Tombs of Menkheperrasonb, Amenose and Another', *Egypt Exploration Society* 86, 112, 42, 226.

Gorringe, H. (1882) *Egyptian Obelisks* (New York: published by author).

Greener, L. (1967) *The Discovery of Egypt* (New York: Viking).

Habachi, L. (1978) *The Obelisks of Egypt: Skyscrapers of the Past* (London: Dent).

Iversen E. (1968) *Obelisks in Exile: The Obelisks of Rome* (Copenhagen: Gad).

Jones, A.H.M. (1962) *Constantine and the Conversion of Europe* (New York: Collier).

Le Bas, Jean-Baptiste Apollinaire (1839) *L'Obélisque de Luxor* (Paris: Carilian-Goeury et Vr. Dalmont).

Long, G. (1846) *The Egyptian Antiquities in the British Museum* (London: British Museum Publications).

Noakes, A. (1962) *Cleopatra's Needles* (London: Witherby).

Parker, J.H. (1876) *The Archaeology of Rome: Chapter IV Egyptian Obelisks* (Oxford Oxford University Press).

Shaw, I. (ed.) (2000) *The Oxford History of Ancient Egypt* (Oxford: Oxford University Press).

Turcan, R., (1996) *The Cults of the Roman Empire* (London: Blackwell).

INDEX